TONBRIDGE & AROUND

THROUGH TIME

Robert Turcan

AMBERLEY PUBLISHING

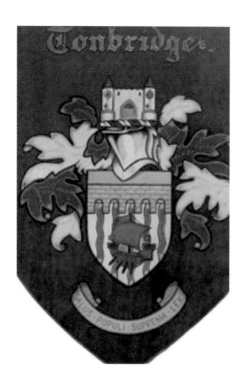

Tonbridge's motto:
Salus Populi Suprema Lex: 'The good of the people is the supreme law' (Cicero)

To Marianne and all the granddaughters of Tonbridge.

First published 2013

Amberley Publishing
The Hill, Stroud, Gloucestershire, GL5 4EP
www.amberley-books.com

Copyright © Robert Turcan, 2013

The right of Robert Turcan to be identified as the
Author of this work has been asserted in accordance with
the Copyrights, Designs and Patents Act 1988.

ISBN 978 1 4456 1594 3 (print)
ISBN 978 1 4456 1603 2 (ebook)

British Library Cataloguing in Publication Data.
A catalogue record for this book is available from the
British Library.

Typesetting by Amberley Publishing.
Printed in Great Britain.

Introduction

Tonbridge is a busy town, but its prosperity has not spoiled its attractiveness and character. In ancient times, a settlement developed here along a route that stretched from London to where the Sussex coast forded the River Medway. Following the Norman invasion, the strategic importance of this point was recognised with the construction of a defensive wooden fort. Fire destroyed this keep, and so a more substantial castle was built of stone by Richard de Tonbridge or de Clare. In the early medieval years that followed, the battlements were attacked and successfully besieged by various warring barons and royalty. During the Civil War, the castle was held by the Parliamentarians, who then decided to dismantle its formidable thick stone walls. The magnificent twin gateway towers, however, were preserved, and have over the centuries become an emblematic symbol of the town.

Before the eighteenth century, Tonbridge, with its few established streets, was not much more than a large village. Trade expanded, however, with development in navigation and transport by water. Heavy industry consequently flourished, including powder mills, corn mills and breweries, with the hops and timber passing downstream. In his *Guide to Kent* (1886), Black described the town as 'quiet and old fashioned, and owing whatever of life and activity it now possesses to the impetus always afforded by railway traffic'.

Certainly the railway, which arrived in 1842, had a dramatic impact on commercial growth. It became possible for businessmen to commute to the metropolis from more agreeable, country residences. As steam locomotives were replaced by diesel and electric models, passenger journeys from Tonbridge station increased to over 4 million each year. Housing estates engulfed a large area south of the river where Barden Park used to stand.

Local light industries unique to Tonbridge included the manufacture of Tunbridge ware and cricket balls. In the twentieth century, printing and the production of gramophone records became prominent.

Tonbridge School also grew to attract much esteem from its early establishment by Sir Andrew Judd in the mid-sixteenth century. The school's Victorian Gothic architecture is an impressive sight to travellers entering the town from the north. Its famous cricket field, known to pupils and staff as the 'Head', has been the nursery for many high-class cricketers, such as Colin Cowdrey.

Tonbridge is close to the genesis of our national game. The surrounding villages all have representative teams, although the factories manufacturing the apparatus (such as bats and balls) have closed.

Hop farming continues to prosper, albeit on a far smaller scale. Its apogee in Victorian times is highlighted by hundreds of oast houses, many of which have now become expensive luxury homes. Fruit farming is another regional specialisation, with greater a emphasis on growing apples and pears than cherries.

Several large country houses stand close to Tonbridge. Penshurst Place is outstanding, but Hall Place and Roydon Hall also have their own individual attractions.

Within the urban environment, motor traffic has brought the greatest changes. The images in this book, mainly taken from Edwardian postcards, exemplify this statement. The streets back then seem peculiarly empty, with only the odd bicycle or horse cart quietly passing by. Congestion has long been a problem for Tonbridge town planners to resolve. There is not a ready solution, as the town is shaped like two funnels spreading north and south from the main bridge. Overall, however, the town's leaders can be proud they have adapted to modern demands, while respecting and conserving the past and avoiding the hideously contemporary.

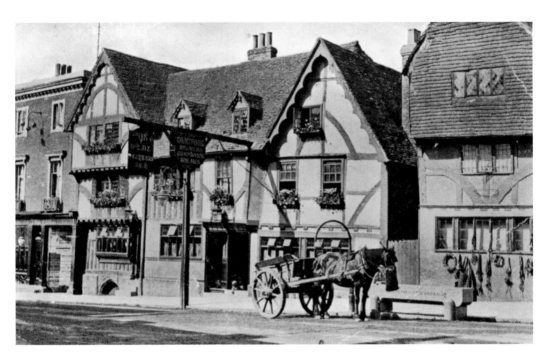

Ye Old Chequers

Resolutely unchanged, this beautiful old coaching inn has been a welcoming hostelry for visitors arriving at Tonbridge over the centuries. Its original timber-framed structure has remained virtually extant, but the Georgian building adjoining has been demolished.

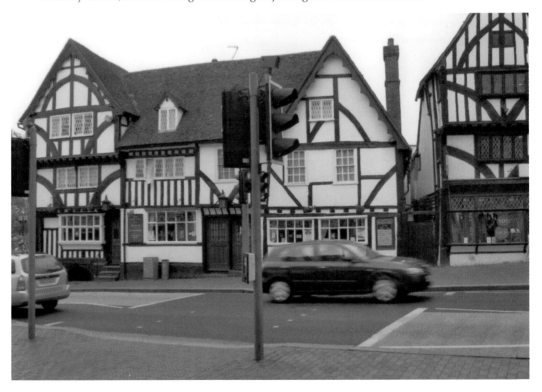

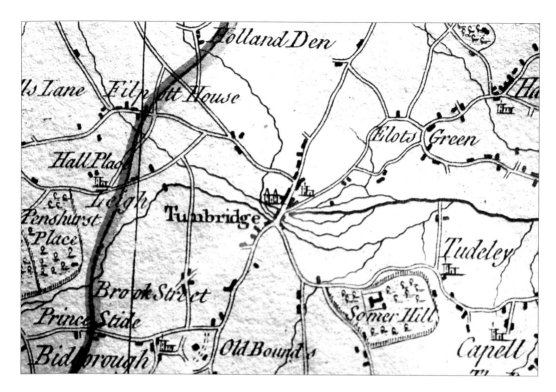

Development of Tonbridge I

Tonbridge emerged as an early settlement on a trackway linking London to Hastings where it crossed the River Medway. The mid-eighteenth century map above illustrates the topography well, showing the main river splitting into four or five smaller waterways in the lower valley areas.

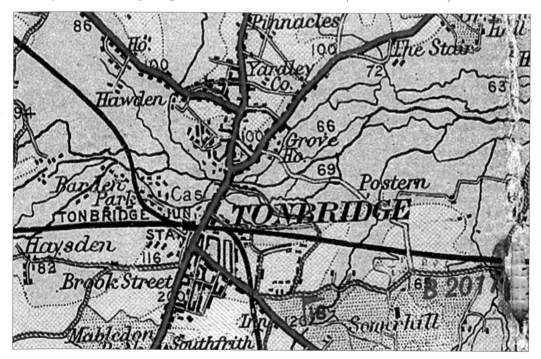

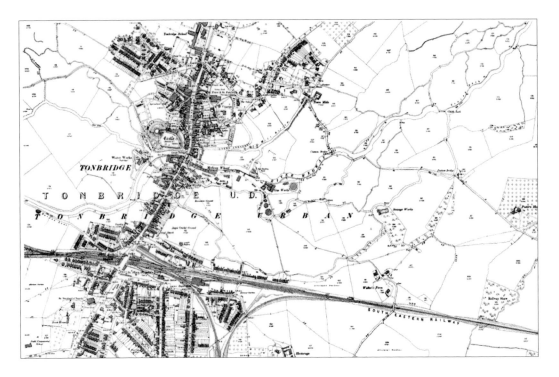

Tonbridge Development II

After the canalisation of the Medway from Maidstone, trade in heavy goods such as coal, wood and agricultural outputs increased considerably. The arrival of the railway in 1842, however, had an even stronger expansive influence. The population grew from around 3,000 to 4,000 within the following decade, and by 1861 it was almost 5,000.

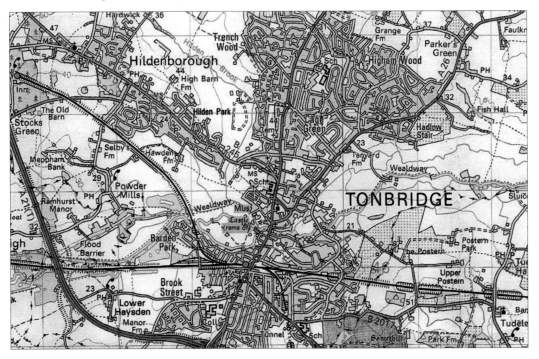

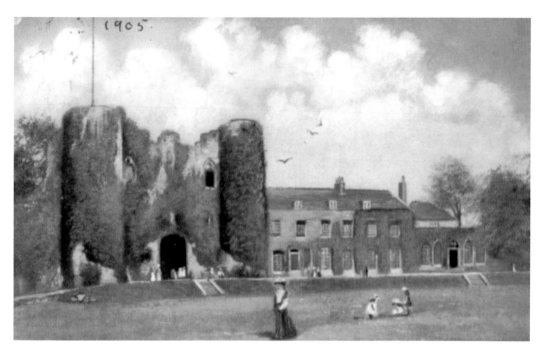

Tonbridge Castle I

Soon after the Norman invasion, a wooden fort was erected by William the Conqueror's kinsman Richard FitzGilbert. The manor and Lowry were part of his rewards. Later, between 1230 and 1260, Richard de Clare, the founder's grandson, built a more substantial stone castle.

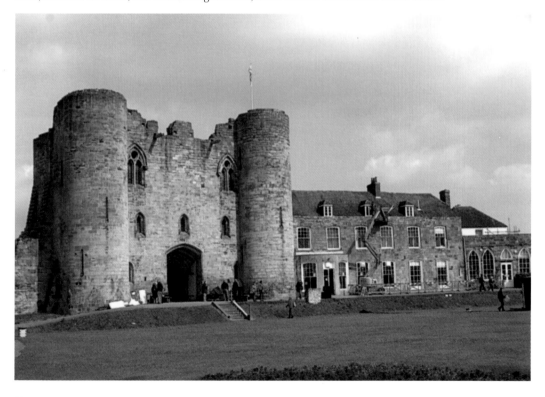

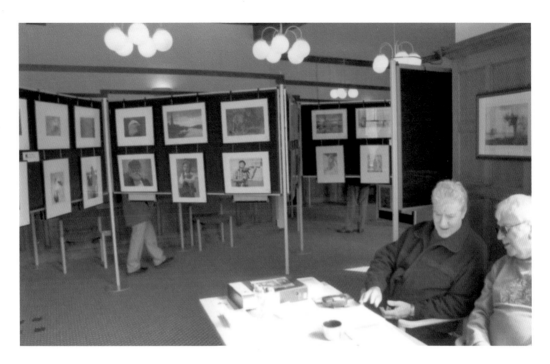

Tonbridge Castle II

After the Civil War, the castle ceased to be an effective fortress, and its curtain walls were gradually dismantled. By the eighteenth century, its then-owner John Hooker was selling its stones for the construction of flood barriers. Later, his son Thomas recycled masonry to build a fine residence next to the twin gatehouse towers. Acquired by Tonbridge Council in 1899, the castle is used for a variety of events, such as the photographic exhibition illustrated above.

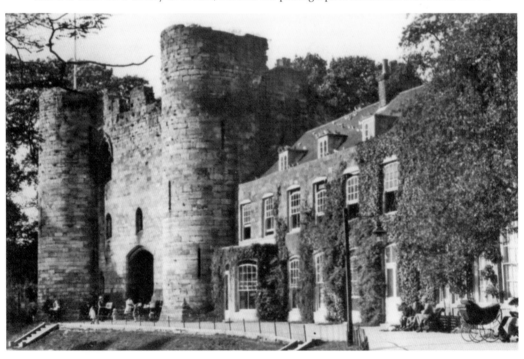

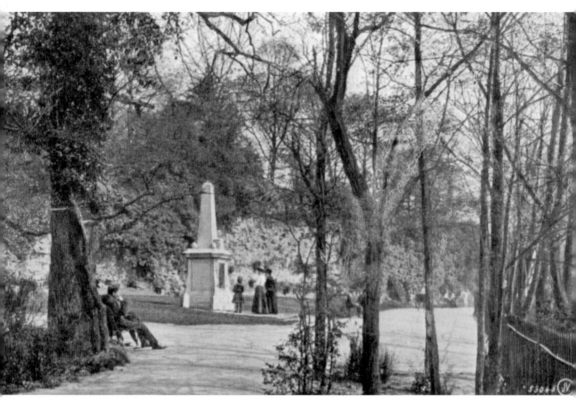

Boer War Memorial I
The Second Boer War claimed the lives of twenty-four townsmen and old boys of Tonbridge School. Their sacrifice is commemorated by a memorial that stands between the old castle ruins and the river walkway.

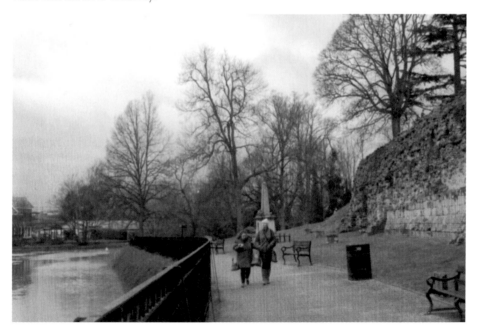

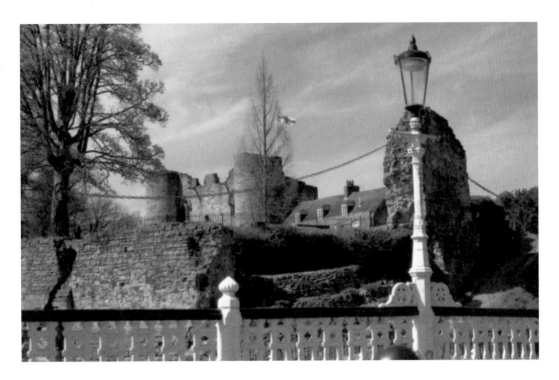

Boer War Memorial II

A lavish civic ceremony in the castle grounds was held to unveil the Boer War memorial. It was headed by Revers Buller, who had a somewhat chequered career as a leading commander in this conflict. His initial defeats at the battles of Colenso, Magersfontein and Stormberg caused his troops to nickname him 'Reverse Bullers'. His reputation and army career, however, was permanently blemished when he was replaced by General French.

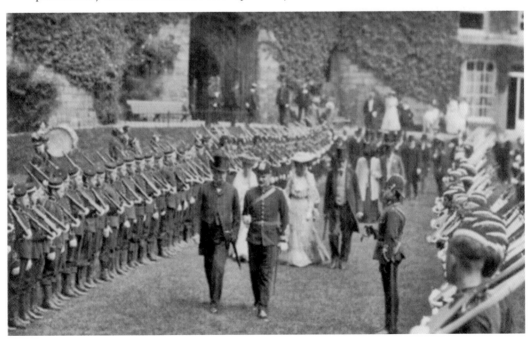

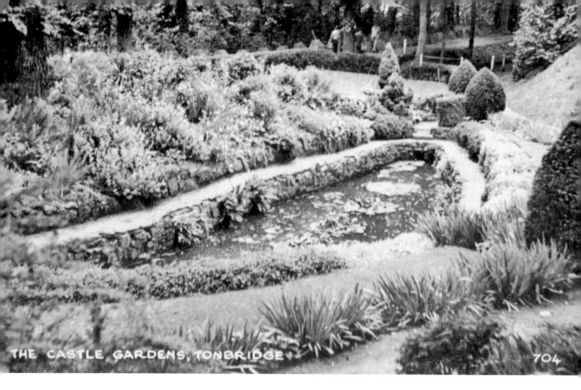

THE CASTLE GARDENS, TONBRIDGE · 704

Castle Grounds

Tonbridge Council pays particular attention to the maintenance of the town's most iconic building. Well-kept lawns and borders provide a romantic backdrop to wedding ceremonies and other social fuctions.

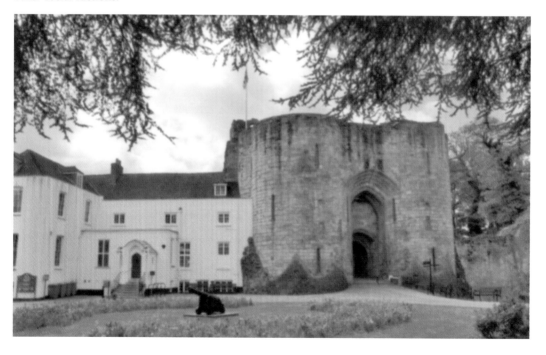

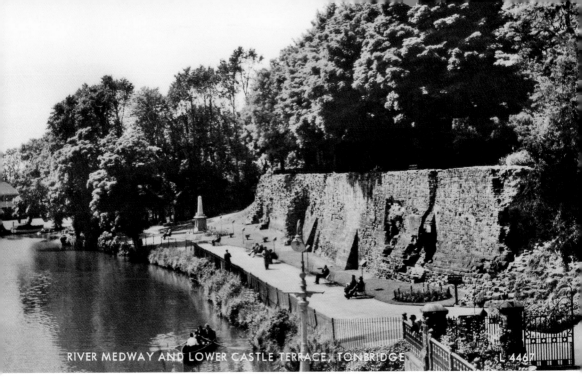

RIVER MEDWAY AND LOWER CASTLE TERRACE, TONBRIDGE L 4467

Riverside Walk

These old postcard images illustrate the superb amenities of broad paths and park benches in this picturesque area of Tonbridge. Thankfully, few changes have marred this well-loved beauty spot since these photographs were taken.

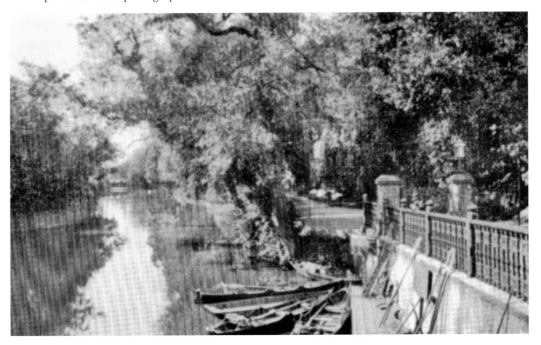

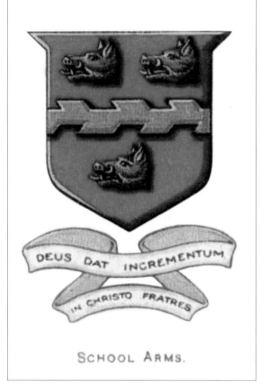

Tonbridge School I
Founded by Sir Andrew Judd in 1553, Tonbridge is one of the country's top public schools. It is a truly excellent academy, taking only 800 boys. Fees are in excess of £30,000 per annum, although there are a large number of scholarships for gifted pupils and many bursaries to assist the less well-off.

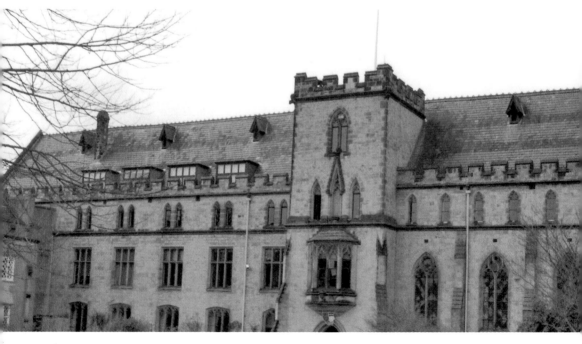

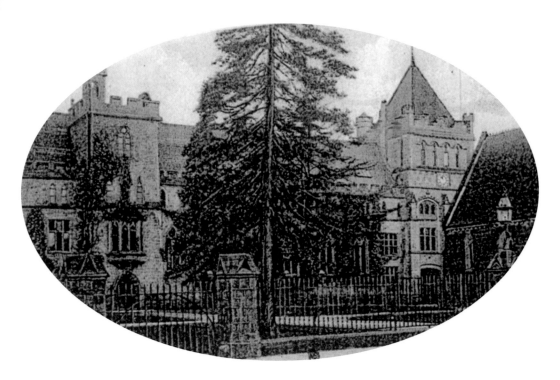

Tonbridge School II

The school's main complex is located at the northern end of the town. These imposing Victorian Gothic buildings are set amid some 150 acres of outstanding grounds. Unusually, the school still maintains close links to the Skinners – its original livery company.

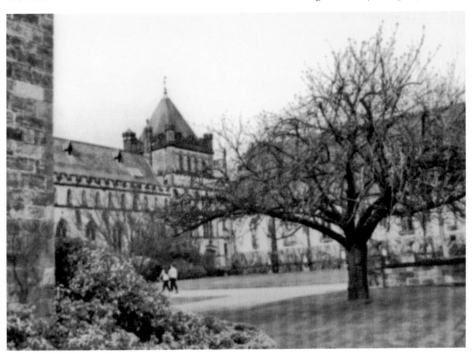

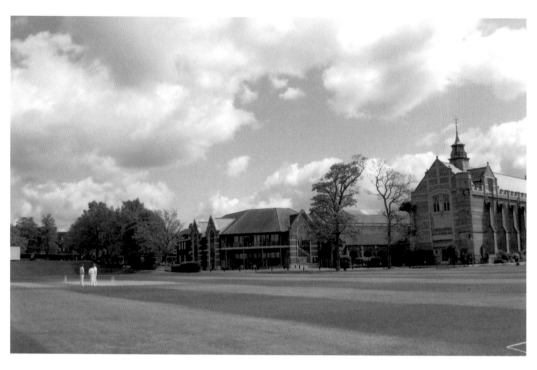

Tonbridge School III

Tonbridge School's splendid playing field is one of the most famous cricket pitches in the country and has been the setting for many memorable contests. Within the school, this area is known as the 'Head'.

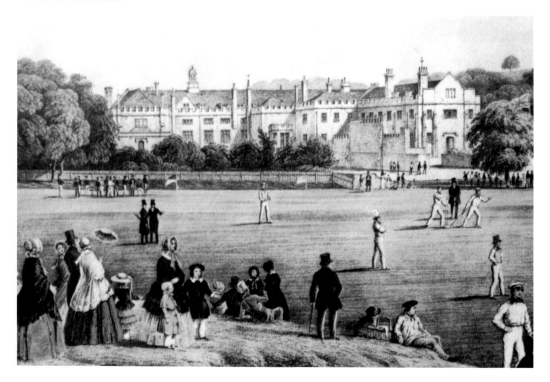

Tonbridge School IV
The old print above shows the original school buildings in 1830. The close-up shot on the right features one of the gateway's heraldic boar heads, which were unveiled by the late Queen Mother upon her visit in the mid-twentieth century.

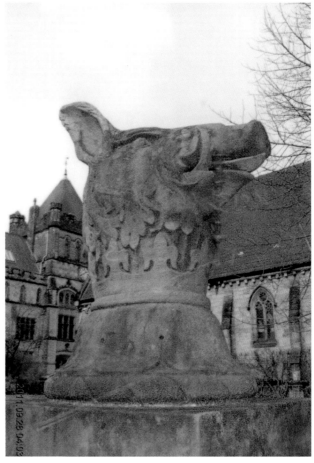

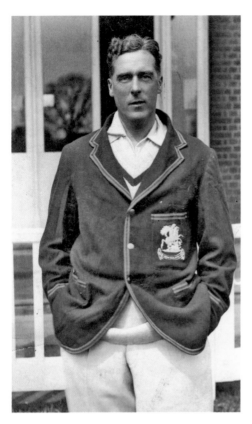

Frank Woolley

Frank Woolley was one of England's greatest all-round cricketers. He was born in High Street, Tonbridge, in 1887, and during a career of over thirty years played many times for England and Kent. His batting was remarkable, both for its elegance and rapidity of scoring. In fact, he is one of the elite 25 who have scored 100 centuries in first-class cricket.

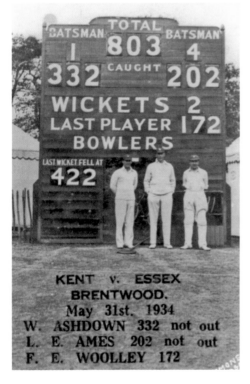

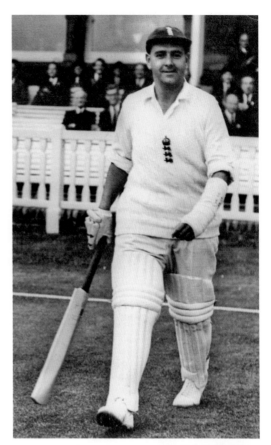

Colin Cowdrey

The late Lord Cowdrey (1932–2000) was born in India into a cricket-loving family. His father sent him to Tonbridge School, where his talent was soon identified. At the tender age of thirteen, he played at Lords against Clifton College, and went on to enjoy a very distinguished career representing Kent and England. One of only two cricketers to be ennobled, he is revered as an affable, stylish batsman of the top order.

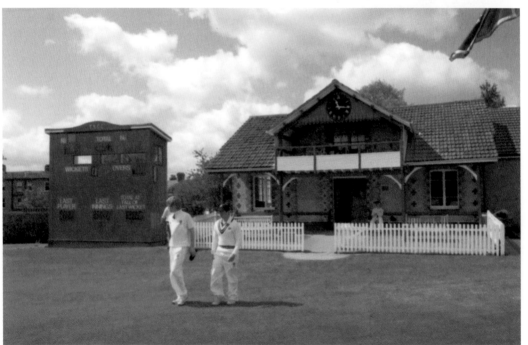

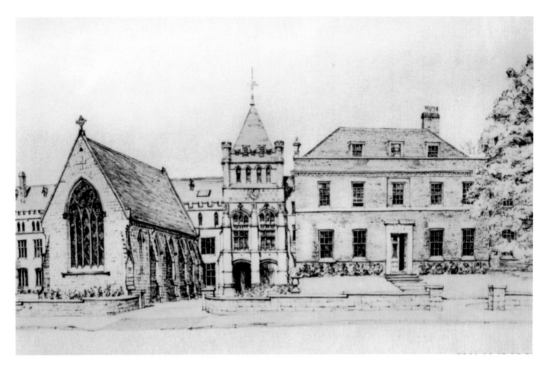

The Chapel, Tonbridge School

Designed by Campbell Jones at the turn of the nineteenth century, the chapel below is a fine, Perpendicular, Gothic building. Although its red-brick walls are a sharp contrast to the grey stone walls of older Gothic buildings, illustrated above, it is an imposing structure nonetheless. Damaged by a fire in 1988, it is now fully restored to its former glory.

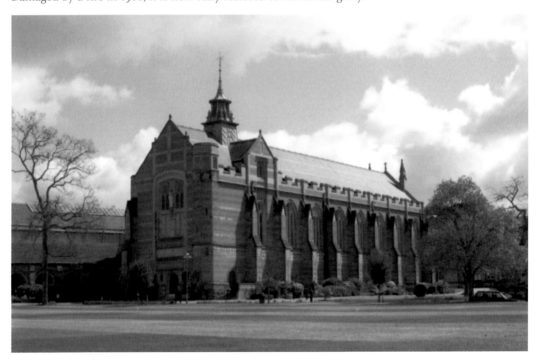

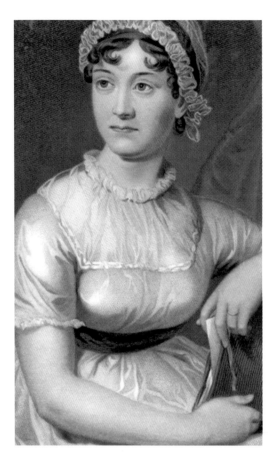

Jane Austen I

Jane Austen had close family ties to
Tonbridge, where her father had been
a pupil and master at Tonbridge School
before becoming a Hampshire parson. Her
novels have now become acknowledged
classics; however, she received little acclaim
during her short life of forty-one years.

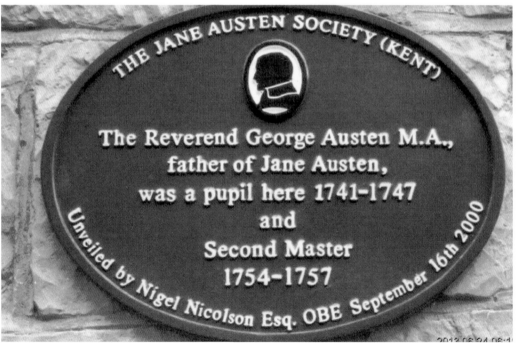

THE JANE AUSTEN SOCIETY (KENT)

The Reverend George Austen M.A.,
father of Jane Austen,
was a pupil here 1741-1747
and
Second Master
1754-1757

Unveiled by Nigel Nicolson Esq. OBE September 16th 2000

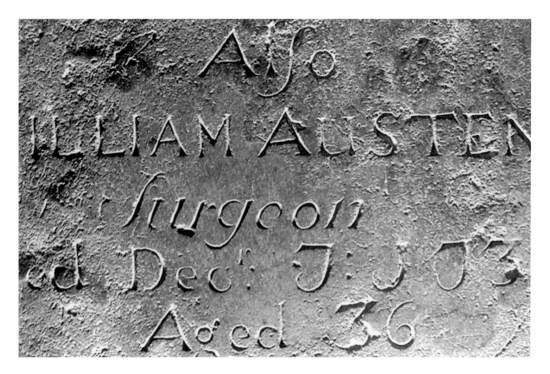

Jane Austen II

The memorial to Jane Austen's grandfather on the floor of the parish church is further evidence of her family links to Tonbridge. William Austen was a surgeon, who lived at No. 174 High Street. Another association, this time by marriage, was the Children family, who lived at Ferox Hall below. John Children was taught by Jane's father at Tonbridge School and went on to enjoy a successful career in scientific research.

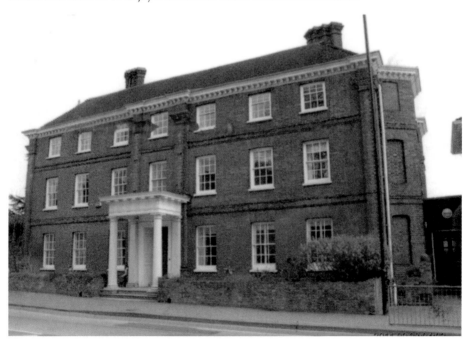

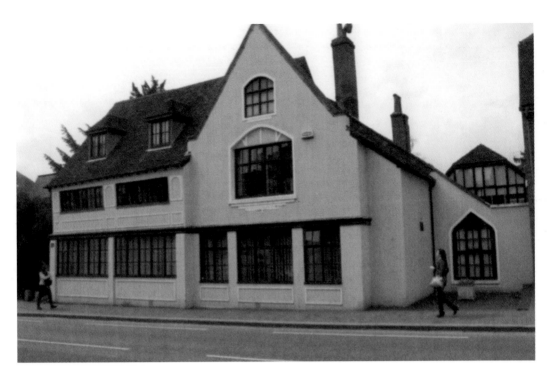

Elegant Tonbridge Properties

With Tonbridge's early development predominantly north of the River Medway, most of its more interesting properties can still be found there. Two good examples are pictured here, with attractive gables containing attic accommodation.

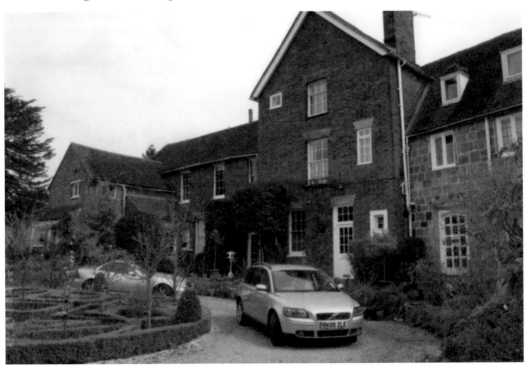

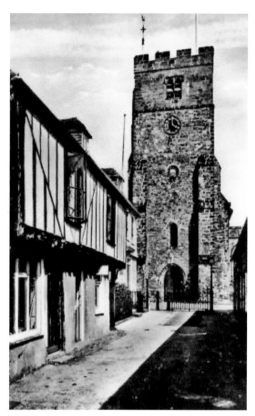

Tonbridge Parish Church I
Until the nineteenth century, the church of
St Peter and St Paul was the largest parish
church in Kent. The first small church,
consisting of the present chancel, was built
in the twelfth century, and a squat tower was
added in the thirteenth. In subsequent years,
there was almost continuous enlargement
and adaptation.

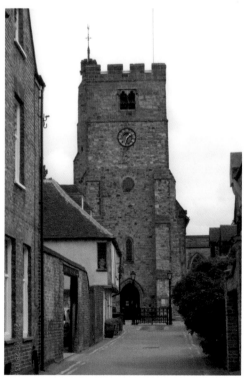

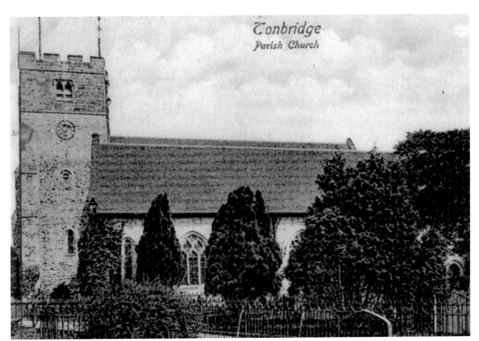

Tonbridge
Parish Church

Tonbridge Parish Church II
In 1877–79, the parish
church felt the need
to expand to counter
the upsurge of local
Nonconformist churches. A
considerable sum of £15,000
was spent on improvements.
Another large-scale scheme
to create two floors and
alter accommodation
arrangements was completed
over a century later. This
was soon followed by further
works to create a hall for a
variety of social functions.

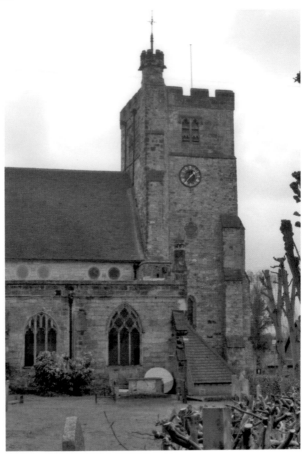

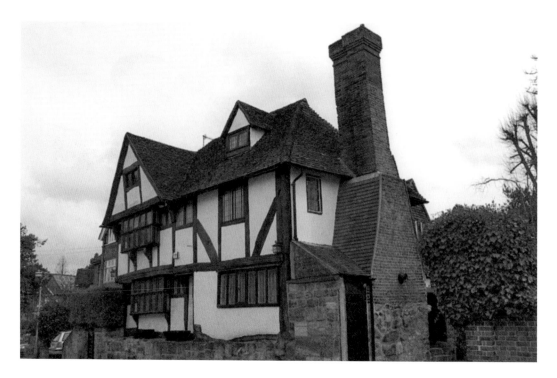

The Port Reeves House

The Port Reeves House in East Street is the town's oldest house. It was once the home of the portreeve, who was a medieval official responsible for collection of tolls on goods and commodities imported into Tonbridge. Constructed between the twelfth and thirteenth centuries, the structure has undergone many alterations to reflect its various uses as a pub and shop. Now it is a beautifully restored Grade II listed building.

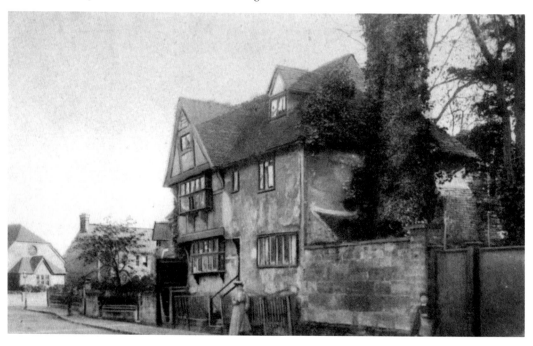

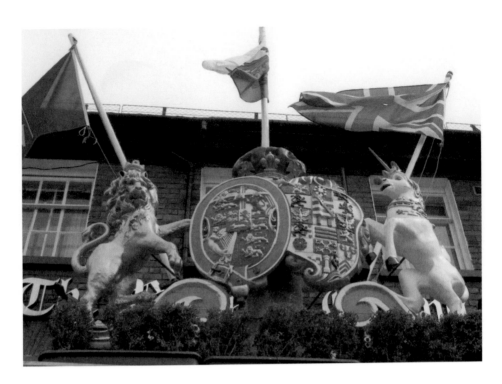

The Rose & Crown

The Rose & Crown is a splendid hotel run by the Best Western group. Its fine Georgian façade hides an earlier Tudor interior. Situated opposite the Chequers and the old market place in the Upper High Street, it was once an important coaching inn on the main highway between London and the coast. The coat of arms over the porch is that of the Duchess of Kent, who often stayed here with her daughter, the future Queen Victoria.

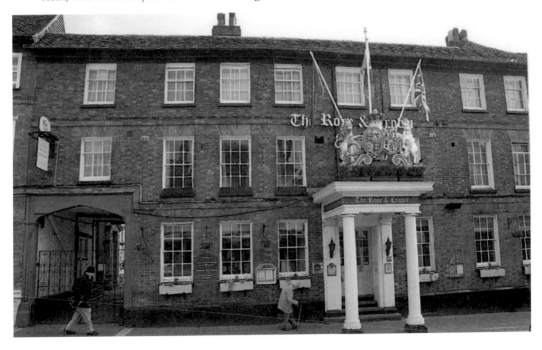

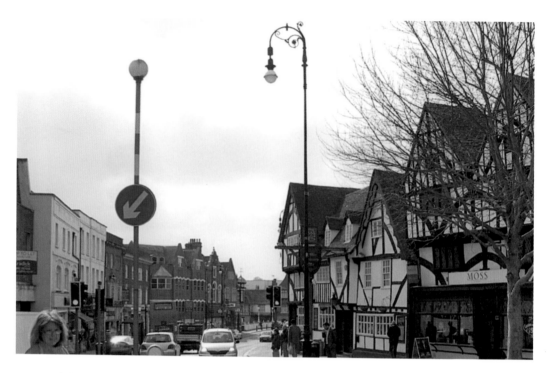

Upper High Street by the Chequers I

The Upper High Street near the Chequers was a centre of much activity throughout the town's past. The town's stocks and whipping post stood here, and it was also the site of public executions. The lovely period properties that adjoined the inn were regrettably destroyed in the 1960s before heritage concerns became more widespread.

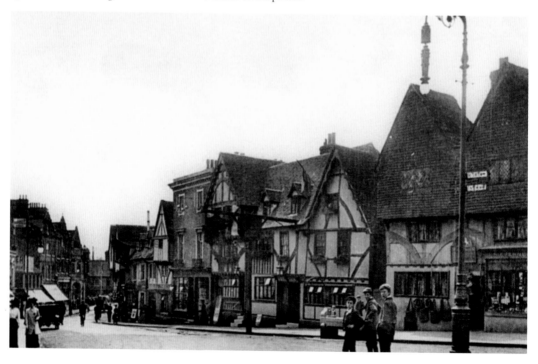

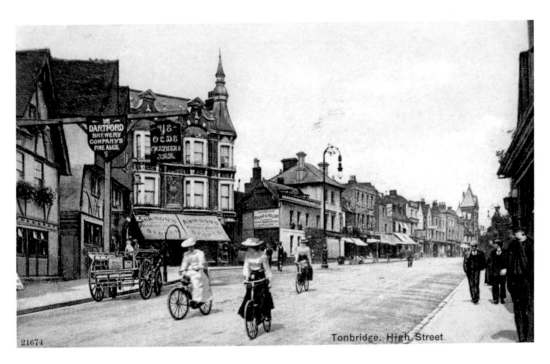

Tonbridge. High Street.

21674

Upper High Street by the Chequers II

This street scene north of the Chequers has changed remarkably little over the past century. Traffic volume and type, however, has been completely transformed. A panda crossing is now required to assist pedestrians, whereas Edwardian cyclists once pedalled with impunity along this highway.

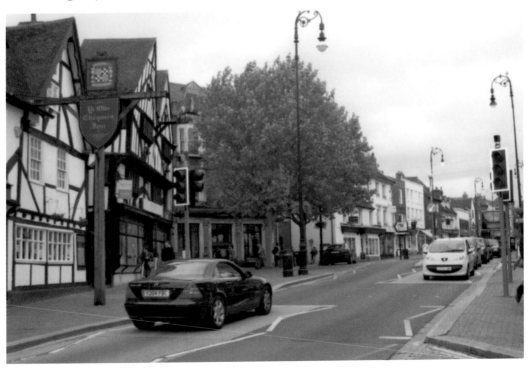

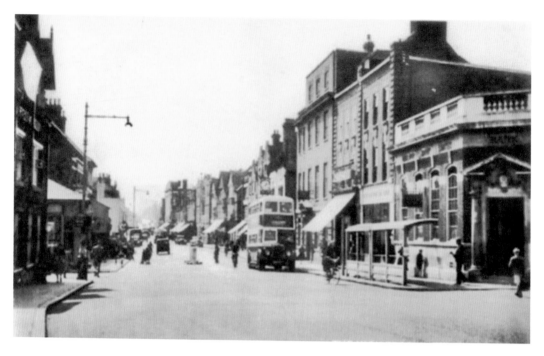

High Street I

The view south from the junction of River Walk and the High Street has not changed much over the past fifty years. There has, however, been a revolution in the type and style of shops lining this High Street. KFC and HSBC are newcomers, while few of the old independent traders survive. Another notable difference is the disappearance of canvas shop awnings.

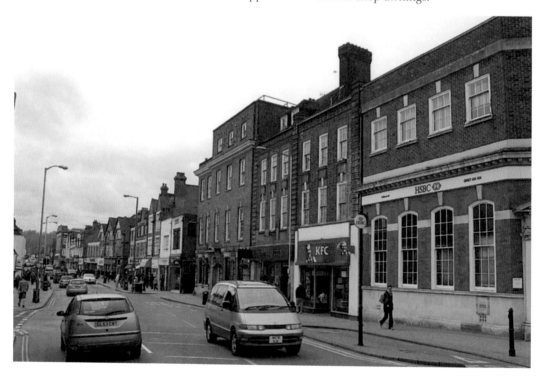

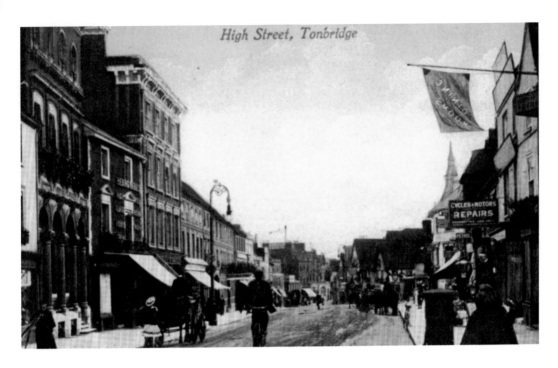

High Street, Tonbridge

High Street II

The then and now shots of this section of the High Street looking south differ mainly because of the present influence of motor transport. An early indication of future trends can be discerned by the shop sign for a cycle and motor mechanic on the right-hand side. The tall, elegant building on the left, which was once the London and County Bank, is unaltered, save for its fascia lettering, which has been removed. Impressively, the local authority has maintained the exact design of street light fittings.

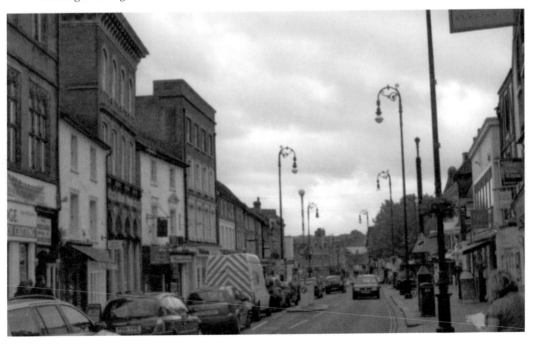

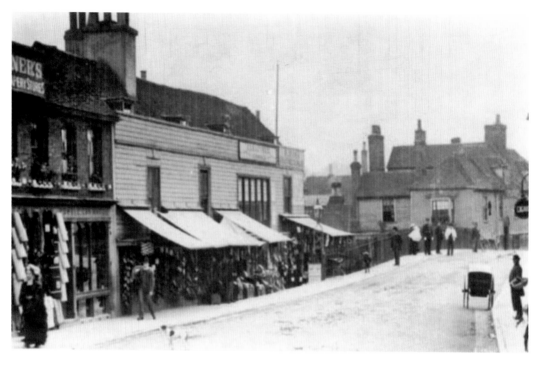

Tonbridge Bridge I
Tonbridge's first bridge was paid for by King Henry VIII and was built of stone with five arches. To cater for the booming stagecoach business of the eighteenth century, an improved replacement, illustrated below, was constructed in 1775.

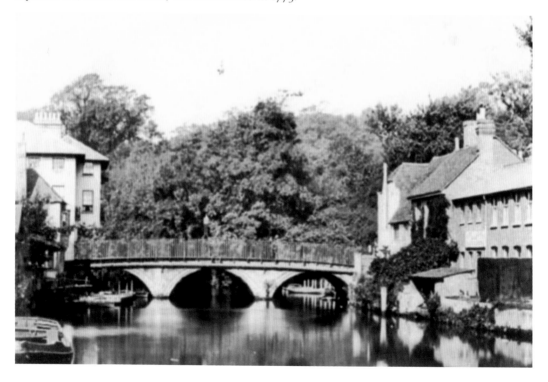

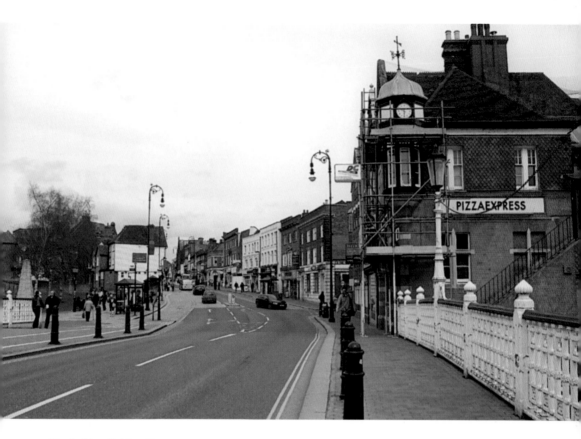

Tonbridge Bridge II

Today's bridge actually dates from 1888, and is a consequence of an even greater increase in horse-drawn traffic through the town at this time. Black bollards have been more recently added in order to protect pedestrians from vehicles.

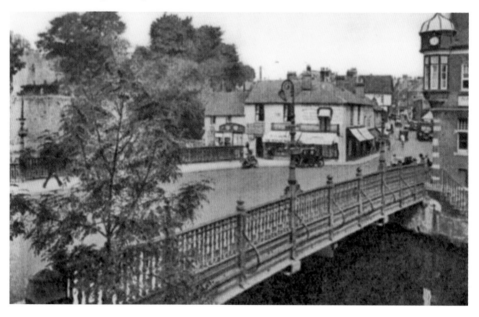

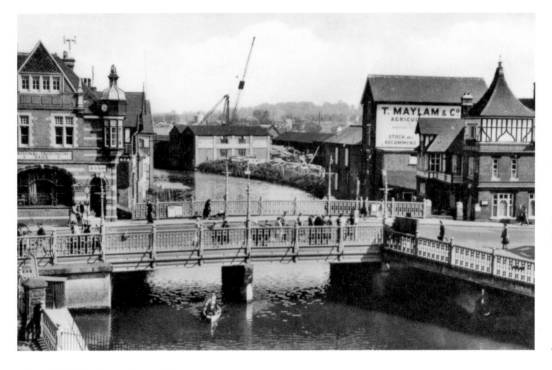

View of Bridge from Castle Grounds

The old buildings close to the bridge survived with few alterations. However, the warehouse previously used by T. Maylam has been converted from commercial use. Upon the southern bank, further redevelopment has taken place. An odd coincidence is that both photographs, taken decades apart, show a high construction crane on the far skyline.

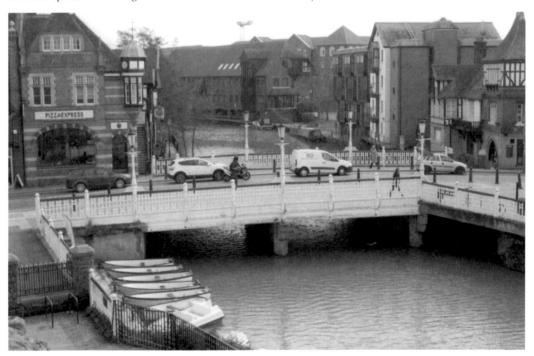

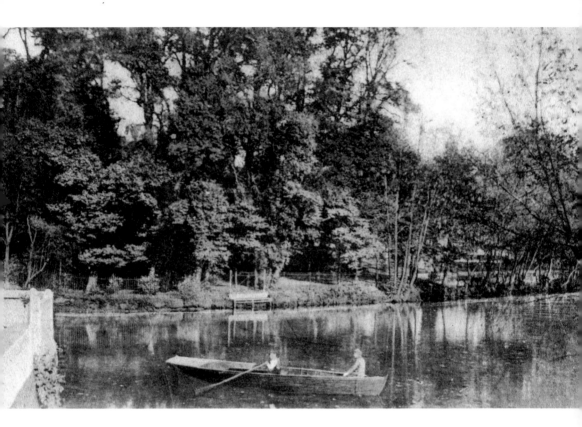

Old River Scenes

These postcards from the Edwardian era illustrate very leafy, tranquil banks along the River Medway in the centre of Tonbridge. Like today, boating was a pleasant diversion on this lovely waterway. The craft, however, were then built of wood rather than the fibreglass of today.

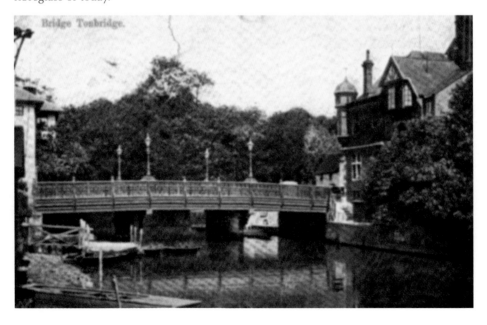

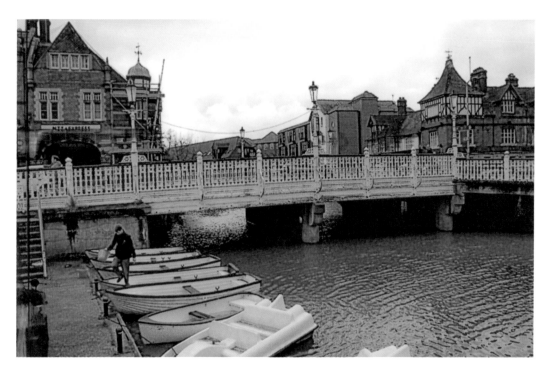

Contemporary River Scenes
On the dull grey summer's day, when these shots were taken, there was no demand for boat hire. The empty boats are tied up and are being forlornly bailed out by their manager.

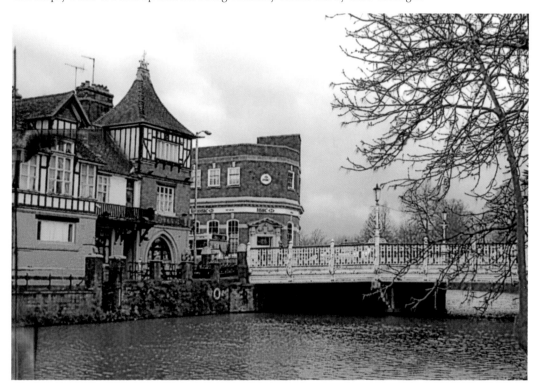

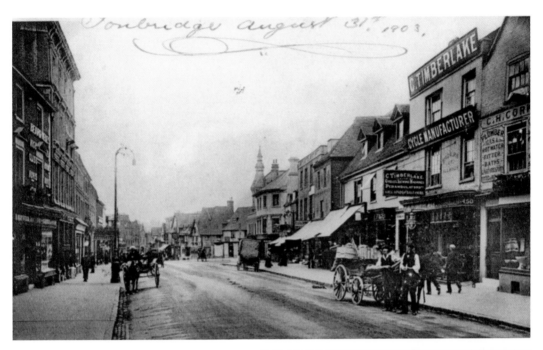

Traditional High Street Retailers
Traditionally, high street retailers took great pride in their window and pavement layouts. Despite the current age of shopping centres, this practice is magnificently continued in Tonbridge today by this stallholder with his colourful display of flowers and produce.

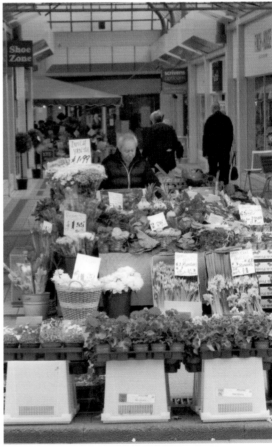

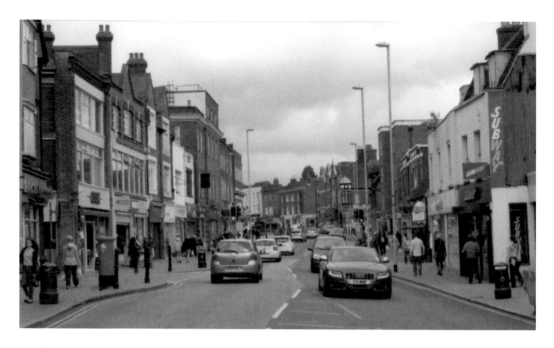

Herding Goats in the High Street

The rustic scene captured below of three people driving a flock of goats to market along the High Street would be unbelievable today. However, even as late as the 1950s, this custom was a normal weekly occurrence in many provincial towns across the country where the volume of road traffic was far less.

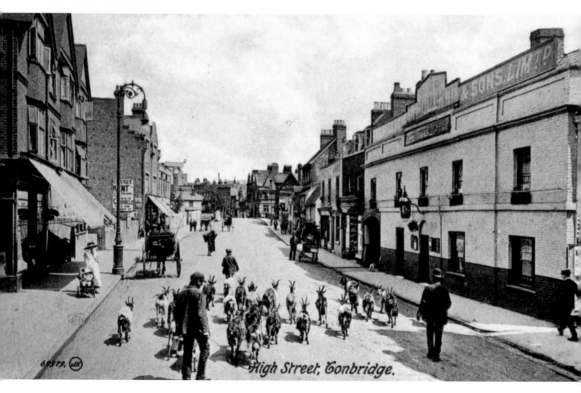

High Street, Tonbridge.

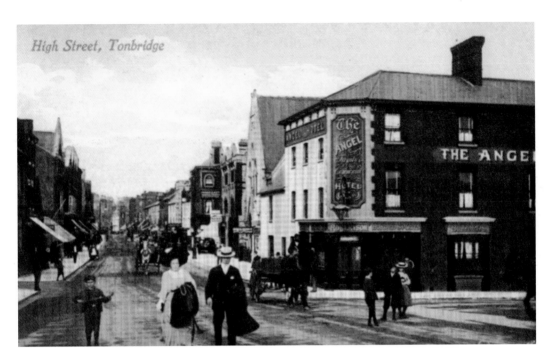

High Street, Tonbridge

Junction of High Street with Vale Road

Close to the railway station, the Angel Hotel must have once been a popular place for refreshment. Now demolished and replaced by a Poundstretcher bargain shop, this busy corner currently suffers the thunder of heavy traffic filtering into Vale Road.

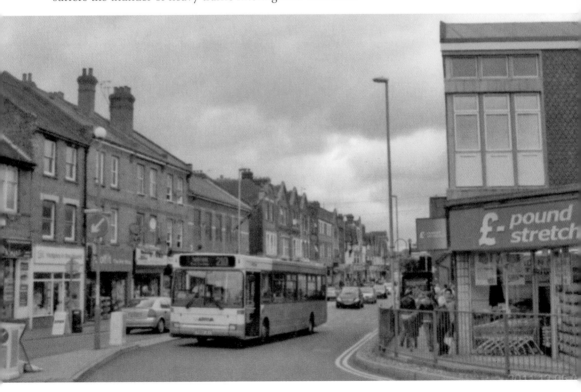

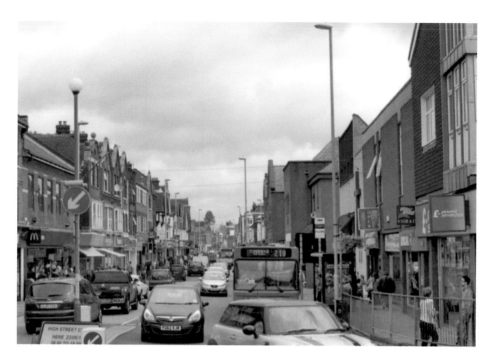

High Street, Facing South

The stream of traffic in the snapshot above illustrates how the motor car has polluted our country towns. A previous attempt by Tonbridge town planners to redirect this heavy flow led to the construction of a bypass along Vale Road. Even though car registrations and population continue to grow, would not it be wonderful to return to the less stressful days of horse-drawn carts?

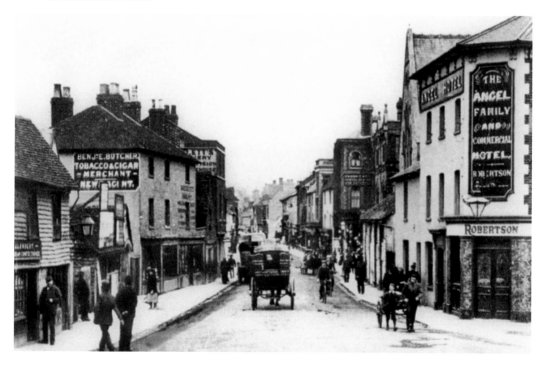

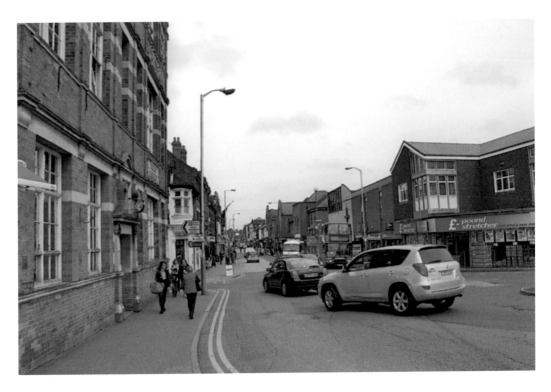

Technical Institute & Library

Opened in 1890, this impressive public building opposite Vale Road was used in 1905 to start Tonbridge Grammar School for Girls. The first nineteen pupils were initially accommodated on the top floor until moving to Deakin Leas in 1913.

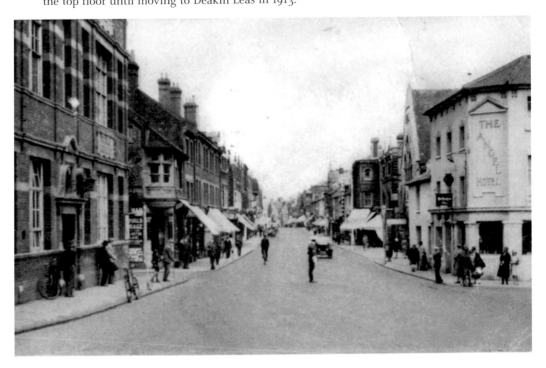

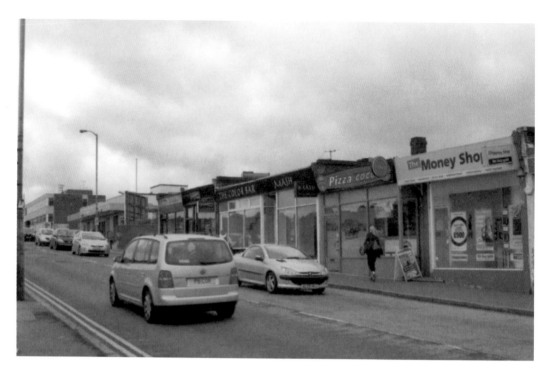

Station Bridge Hotel

Like the Angel Hotel, the Station Bridge Hotel has disappeared from the area close to Tonbridge station. The brewers supplying its beer were F. Leney & Sons, who ran the Phoenix Brewery, Wateringbury, before it was taken over by Whitbread and Co. in 1927. The vintage taxis featured in this old image date from at least the early 1920s.

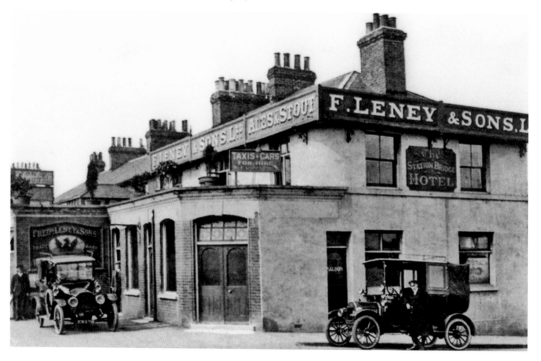

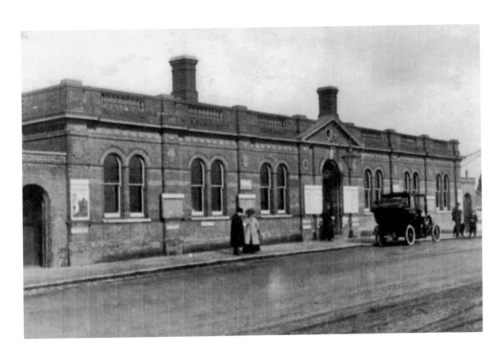

Tonbridge Railway Station

The coming of the railway in 1842 had an enormous economic impact on Tonbridge. The first line operated by South Eastern Railways ran from Redhill through to Folkestone. It was a rival to the London, Chatham & Dover Railway, who had a more direct line to the coast. To counter this competitor, a new line via Sevenoaks and Orpington to London was built in 1868. At this time, the station building was moved from its old site near the ancient priory foundations to its present one. This building is still in use today, following many makeovers – the latest streamlined version, illustrated below, was completed in 2011/12.

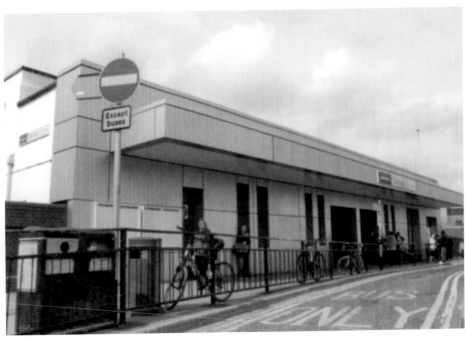

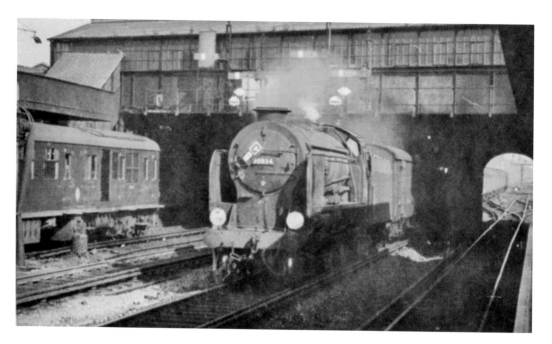

Railway Disaster, 1909

An accident involving a head-on crash of locomotives in 1909, caused by signal problems, led to the death of two railwaymen. This tragedy resulted in the diversion of a later train carrying King Edward VII and Queen Alexandra to Biarritz. Electrification of this main route to London only occurred in 1961; steam and then diesel engines continued to be used on the Redhill line until its final electrification in 1994.

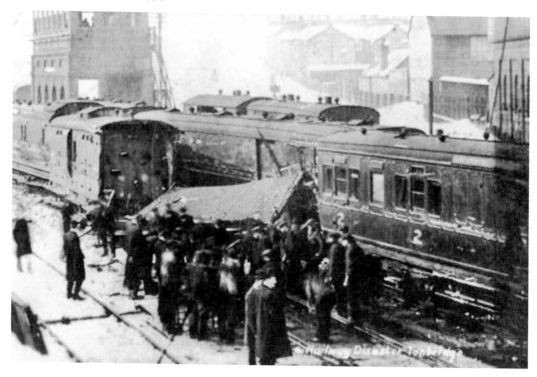

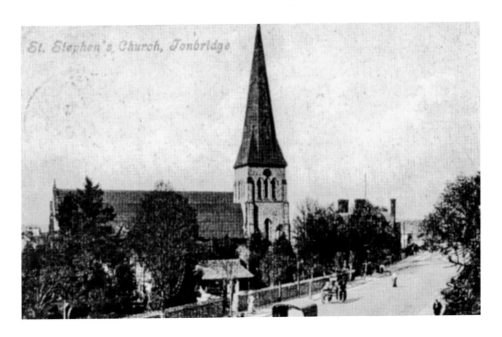

St Stephen's Church, Tonbridge

The coming of the railway presaged considerable housebuilding at the south of the town. By 1848, the church authorities realised that a new church was needed for the growing population. Accordingly, a plot of land was purchased for £200, and building work by local developer Mr Punnet was completed in 1852. Further expansion was necessary in 1868 and the 1870s. Today, this parish comprises of some 18,000 people. The churchyard was soon closed for further burials in 1889, as it had quickly been filled by overflow from the full parish churchyard and the high death rates associated with Victorian epidemics.

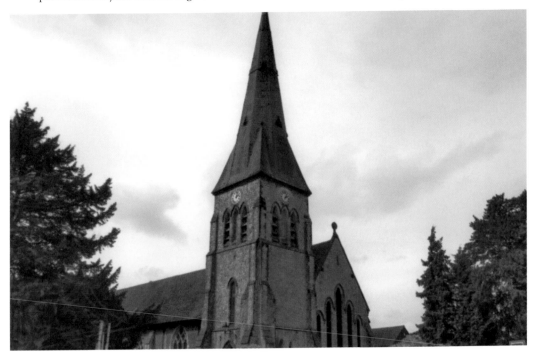

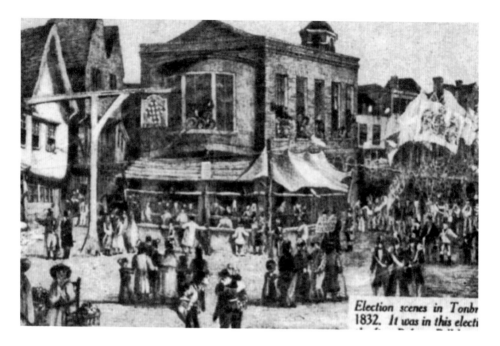

Election scenes in Tonbr 1832. It was in this electi

General Elections at Tonbridge

The print above shows crowds gathering for the 1832 general election, the first poll following the Reform Act. The old Town Hall, which was demolished long ago, is at the centre of activities. Later, the porch of the Rose & Crown became the spot where election results were announced by returning officers. The jubilant photograph below shows Col Herbert Spender-Clay, MP (Conservative), following his successful election. He was an archetypal 'old school' politician, with a patrician background and aristocratic connections.

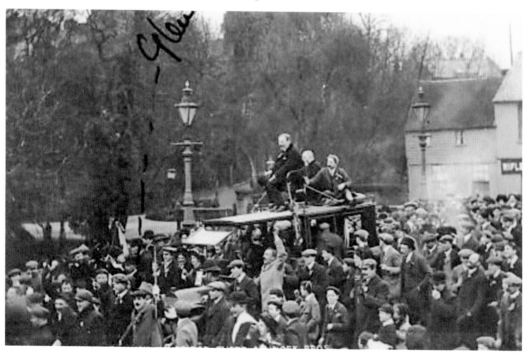

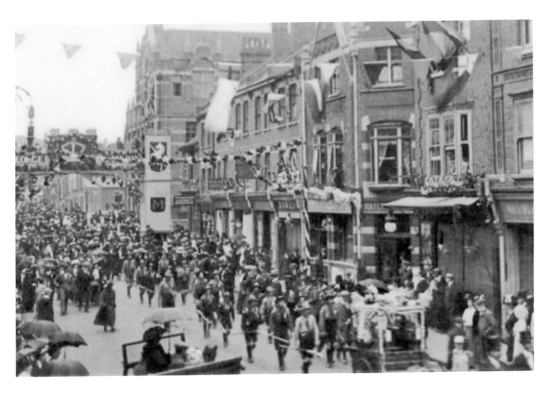

Public Parades

The celebrations above were held to mark the coronation of King Edward VII in 1911. However, Tonbridge was more used to the parades associated with the National Fire Brigade Union's annual 'jamboree' below.

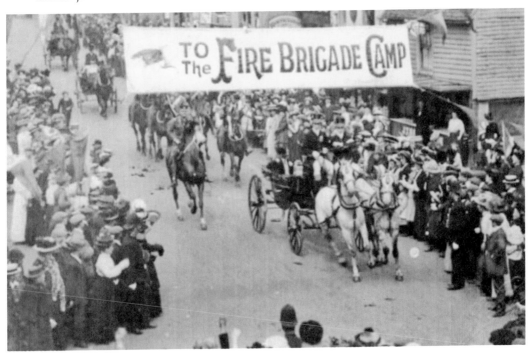

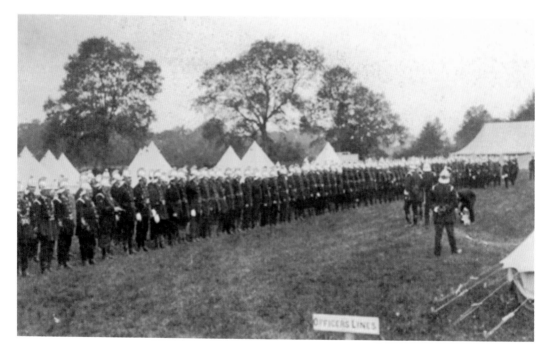

Tonbridge Week, National Fire Brigade Union

The National Fire Brigade Week was probably Tonbridge's most photographed event. The two images on this page have been selected in order to illustrate the vast scale of activities involving hundreds of firemen from across the country.

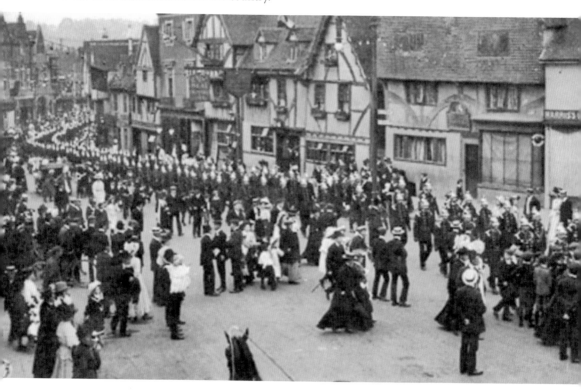

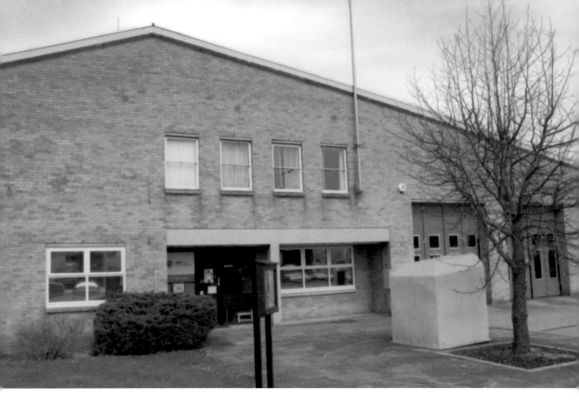

Tonbridge Fire Stations I

Tonbridge Fire Brigade have been based at their headquarters in Vale Road since 1985. They moved there from their former home, situated near the castle (*below*). This was their second home, built in 1898 and opened by the chairman of the local council.

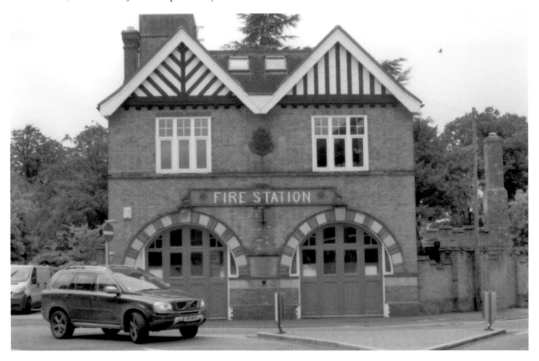

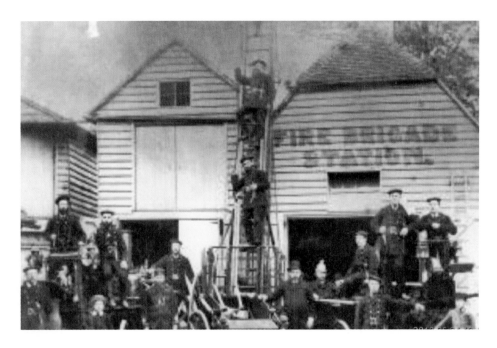

Tonbridge Fire Stations II

The weatherboarded fire station above was in Crown Yard, behind the High Street. In late Victorian times, firemen were mainly volunteers, and their pumps were either hand moved or drawn by horses. The fine postcard below shows a proud Tonbridge team of this period, resplendent in polished brass helmets. Even earlier, hand fire pumps were typically kept in the porch or vestry of local churches.

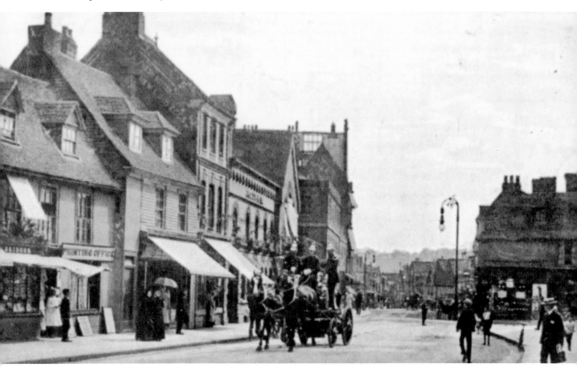

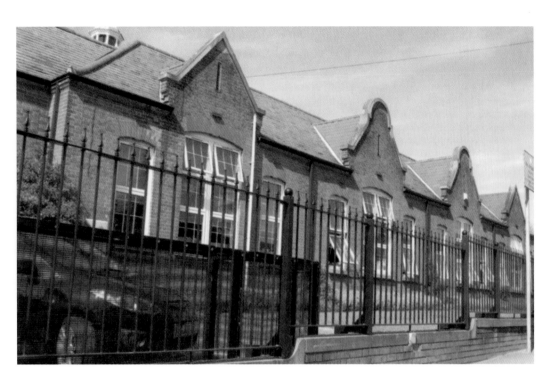

Slade School

The Slade School serves an area of the town that comprises a network of narrow Victorian streets, surrounded on three sides by local playing fields, the castle and the Upper High Street. During the Second World War, three slit trench shelters were built here as Tonbridge was considered particularly vulnerable to German bombing. This junior school, with its distinctive Edwardian architecture, currently has 320 pupils with some eighteen teaching staff.

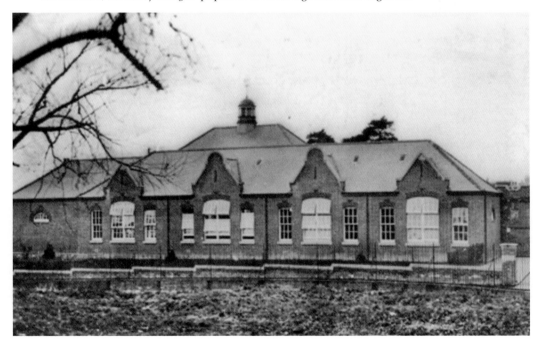

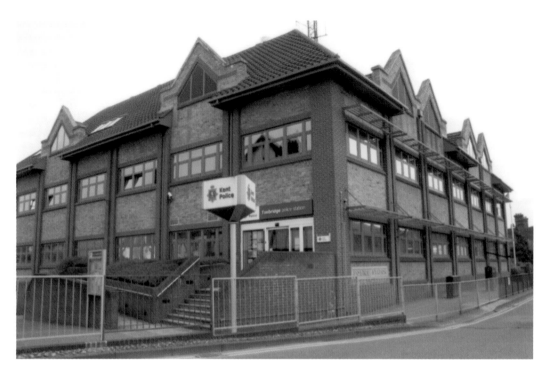

Tonbridge Police

Like Tonbridge Fire Station, the present Tonbridge police station is a modern and well-designed building at No. 1 Pembury Road. Today, most of the police staff use motorised transport. However, when the Tonbridge team, below, were on duty a century ago, they had to rely on walking, bicycles and a horse kept for a mounted officer.

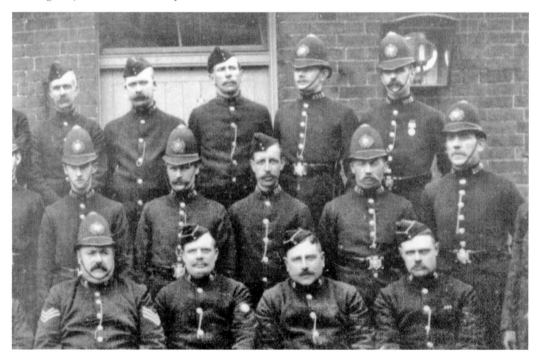

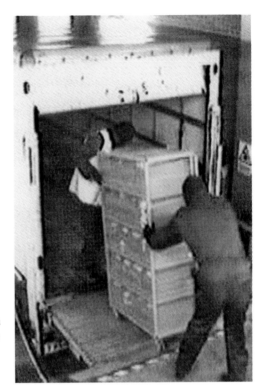

Tonbridge Heist

The Tonbridge Heist in February 2006 was famous for being the biggest cash robbery in peacetime history anywhere in the world. A large armed gang kidnapped the manager of a high-security cash warehouse, run by the firm Securitas in Vale Road. Some of the criminals responsible are still at large, and only part of the funds have been recovered.

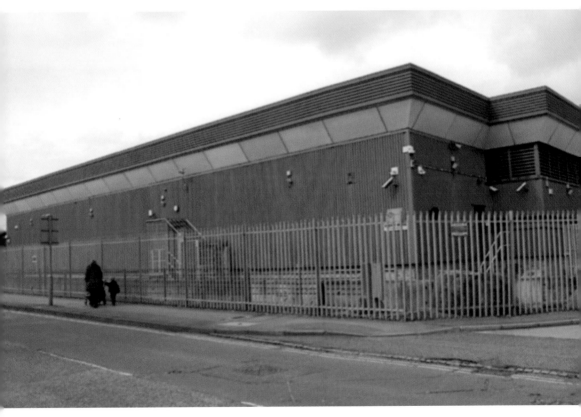

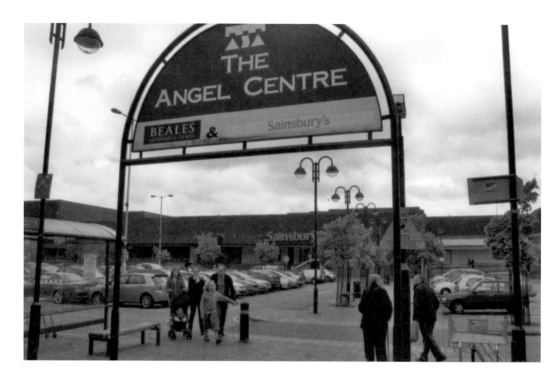

Angel Cricket Ground

The Angel Cricket Ground, pictured below, was opened in 1869, and was the venue for many County games until 1939 when it was taken over by Tonbridge Angels Football Club. Its nursery for young cricketers was instrumental in furthering the careers of many famous cricketers, such as Colin Blyth and Frank Woolley. Following considerable controversy, including a High Court challenge, the landlords – Tonbridge Council – redeveloped the area into the Angel Shopping Centre.

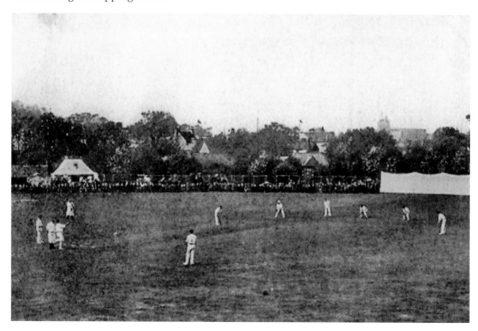

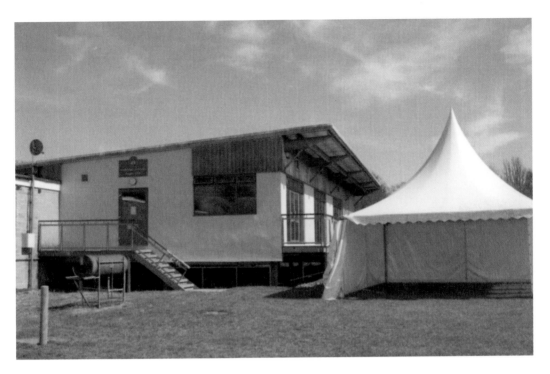

Tonbridge & Juddians Rugby

Tonbridge Rugby Club was formed in 1904 and merged with Old Judians in 1999. They play in National League 3 South East and are based at the Slade Groud. The picture above shows preparations for a recent beer festivval while below the fifth team front row prepare to scrum down.

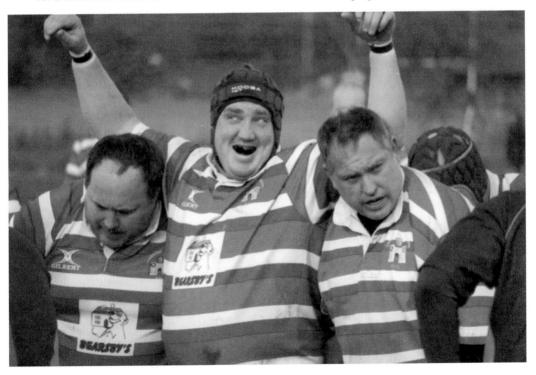

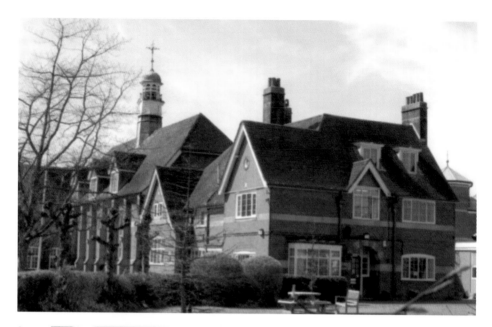

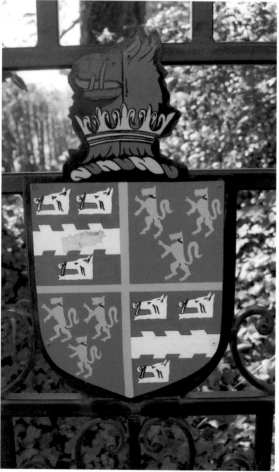

The Judd School

The Judd School was established by the Worshipful Company of Skinners in 1888. It is a voluntary aided grammar school for 935 pupils. The sixth form includes sixty girls, but the lower forms are for boys only. They moved to their present site in 1908 where the new school, costing over £8,000, was built from designs by architect Campbell Jones. The school has a high reputation and is ranked as 'outstanding' by Ofsted.

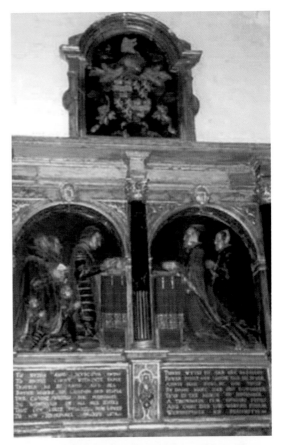

Sir Andrew Judd

Judd was a very successful sixteenth-century merchant adventurer, who amassed a large fortune from international trade and finance. He was a member of the Skinners' guild, and eventually rose to become the Lord Mayor of London. With his wealth he endowed many educational charities. The picture below shows where part of the original 1888 Judd Commercial School was founded. Buried in St Helens, Bishopsgate, London, the impressive marble tomb shown on the right reflects Sir Andrews's éminence grise.

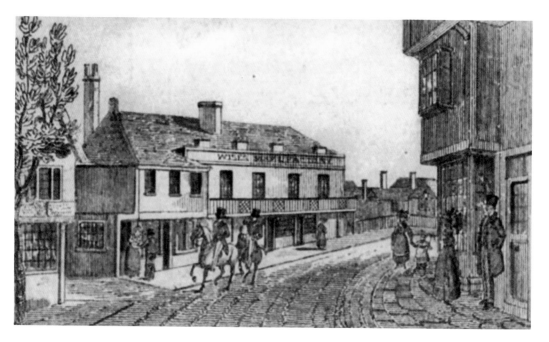

Tunbridge Ware I

This unique form of wooden inlaid marquetry was developed and manufactured in the Tonbridge and Tunbridge Wells area. It is constructed from minute strips of timber, in a great variety of natural colours and types. These were first used to build up geometric patterns and, later, floral decorations, landscape scenes, buildings, animals and birds.

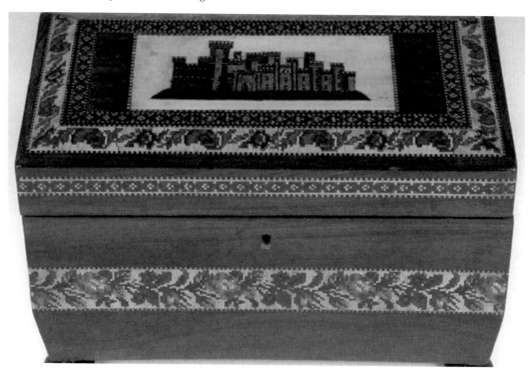

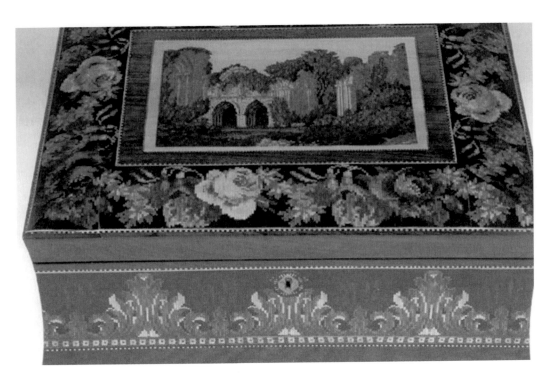

Tunbridge Ware II

One of the two manufacturers of Tunbridge ware, Wises (1746–1876) in Tonbridge. Their works stood at the north end of the Big Bridge on the east side. Here they produced a vast range of boxes and other useful wooden items to be sold to tourists visiting the fashionable spa of Tunbridge Wells.

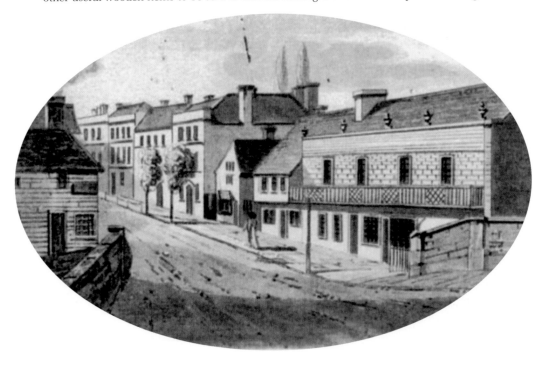

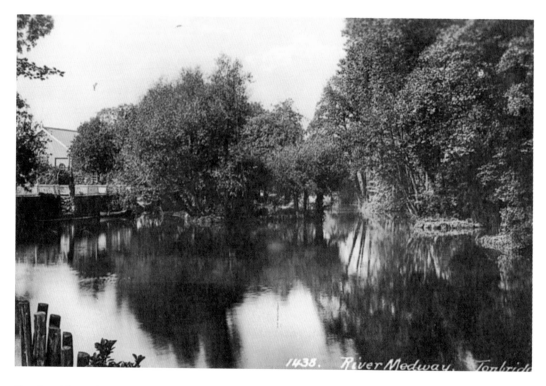

Boating Along the Medway

The two sepia photographs on this page illustrate the enormous potential that the waterways of Tonbridge offered for quiet leisure boating. Fortunately, these streams have remained unpolluted and still attract many rowers and small powerboats.

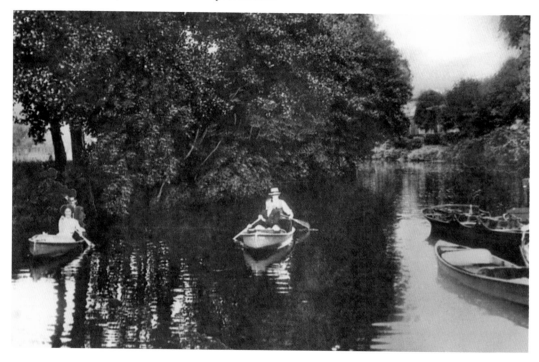

Haysden Country Park
Haysden Country Park was opened by Tonbridge and Malling Council in 1988. It comprises two lakes called Barden and Haysden, and covers over 160 acres of glorious natural countryside and surrounding streams of the River Medway. Designated a Local Nature Reserve in 2008, surfaced footpaths allow easy access for walkers and cyclists.

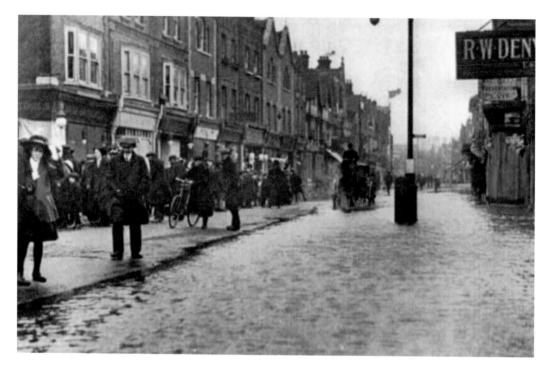

Flood Protection

Over the years, Tonbridge has been vulnerable to flooding from the overflowing Medway. The photograph above is one of many that record these emergencies. The last one of particular note was in 1968, when the whole town became submerged. To prevent reoccurrences, a flood barrier was constructed at Leigh in 1981. When required, this scheme provides a means of storing up to 1,230 million gallons of water on farmland west of the town.

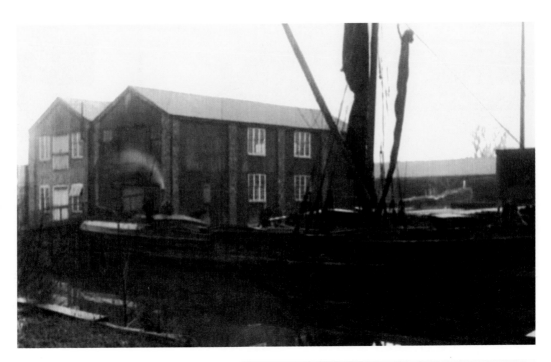

River Barges

Before the railway arrived at Tonbridge in early Victorian times, bulky loads were transported by barges from Maidstone, Rochester and beyond. The Baltic sawmills in particular took advantage of this cheap and effective way of carrying heavy timber. Thames sailing barges, like the ones pictured here, were capable of carrying 90 tons of freight in these shallow riverine and coastal waters.

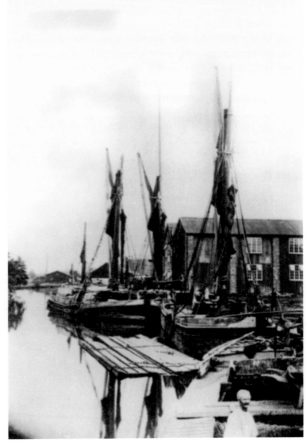

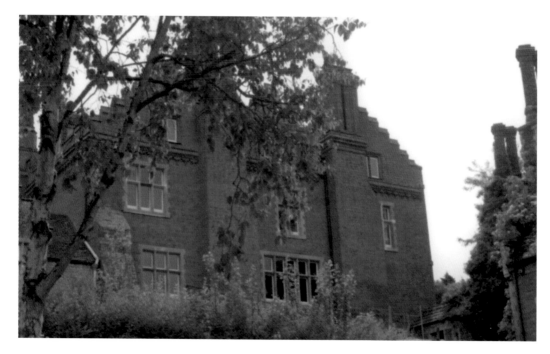

Roydon Hall I

Roydon Hall, East Peckham, was built in 1535, and was the seat of the Twysden family. The first baronet (Sir William) was a courtier, scholar and sailor. His eldest son and heir, Sir Roger, was a Parliamentarian and English historian. His strong allegiance to the Royalist cause during the Civil War led to imprisonment and sequestration of funds. A younger brother, Sir Thomas, who lived at Bradbourne Hall, West Malling, was a lawyer and a famous judge. The imposing red-brick mansion, shown from two angles here, with its distinctive crow step gables, was considerably remodelled around 1870.

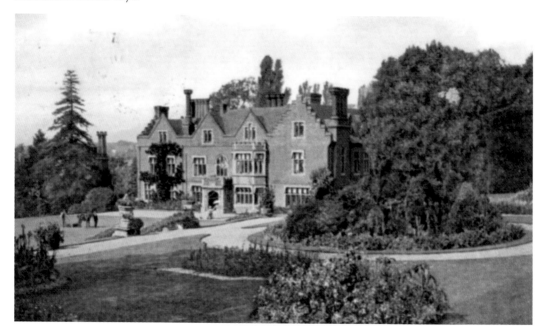

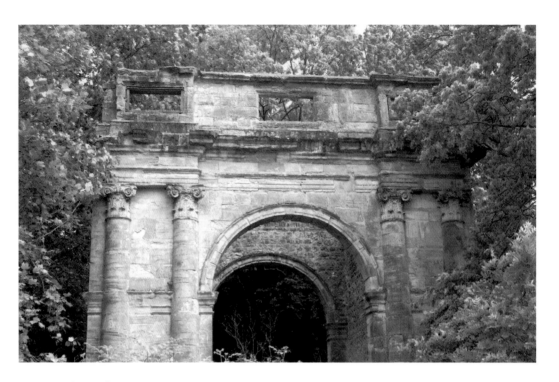

Roydon Hall II

The picture below shows the beautiful setting surrounding Roydon Hall, nestled in the folds of lush rolling countryside. On the corner of a narrow country lane, skirting the north of this parkland, a derelict folly stands amid woodland. It is opposite a farm track, indicating this might once have been a gateway to an impressive sweeping private driveway.

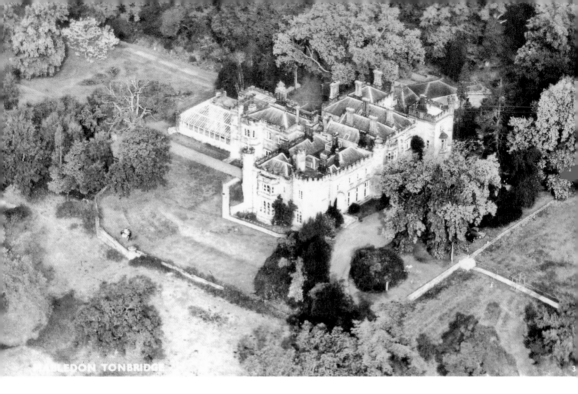

Mabledon

In 1805, James Burton, a local builder and developer, built Mabledon between Tonbridge and its upcoming neighbour Tunbridge Wells. His tenth son, Decimus, who was brought up here, sold the house to rich London banker John Deacon in 1828. Decimus is famous for his acclaimed large-scale schemes to build pseudo-classical developments in Tunbridge Wells.

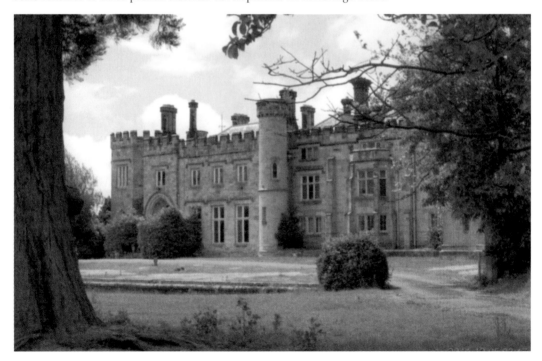

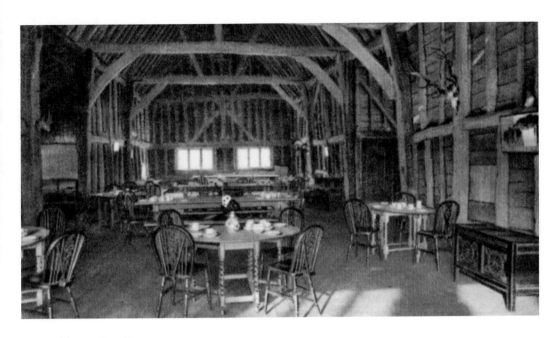

Old Barn Tea House

The Old Barn Tea House at Stocks Green near Hildenborough was run by the Tomlinson family until it was sold in 1993 and became a nightclub. However, an almost totally disastrous fire ended its development and the ruins were converted into a home.

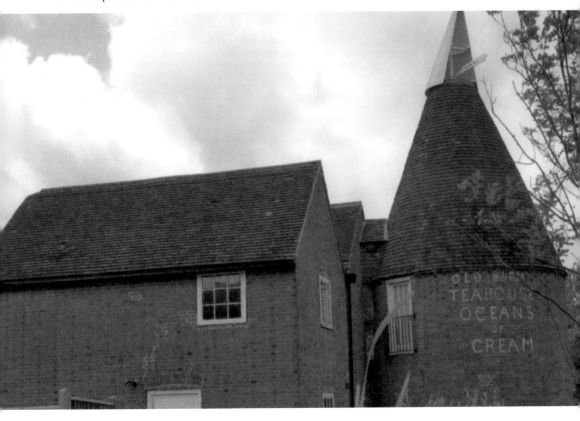

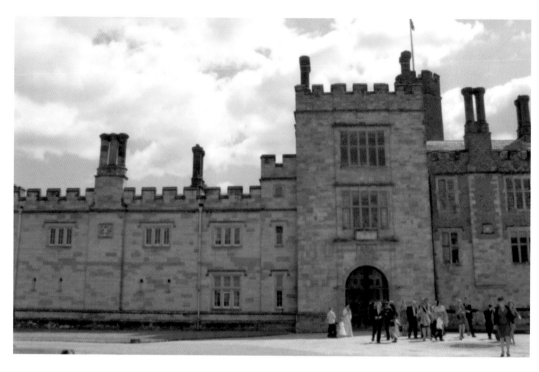

Penshurst Place I

Penshurst Place near Tonbridge is the ancestral home of the Sidney family. The original medieval home is an example of completed fourteenth-century domestic architecture in its original location.

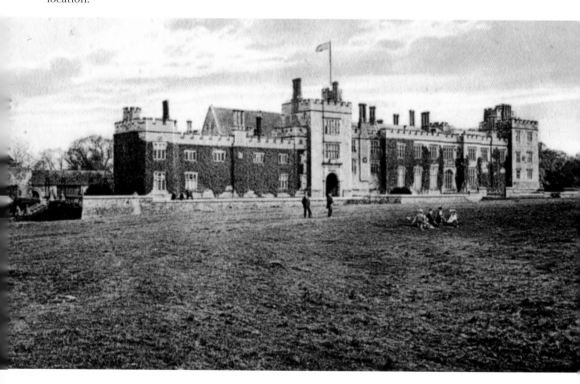

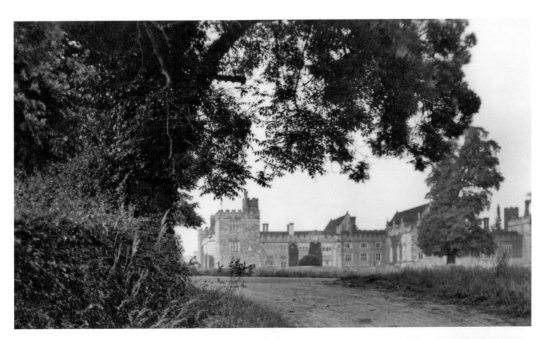

Penshurst Place II

The grounds of Penshurst Place are as renowned as its historic walls. They contain a 10-acre rose and lavender garden, which is the oldest Elizabethan garden of this kind in private ownership. Its records date back to 1346, and with over 3,000 rose plants it is now a much-admired feature for visitors.

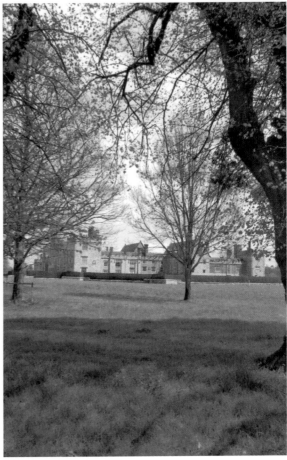

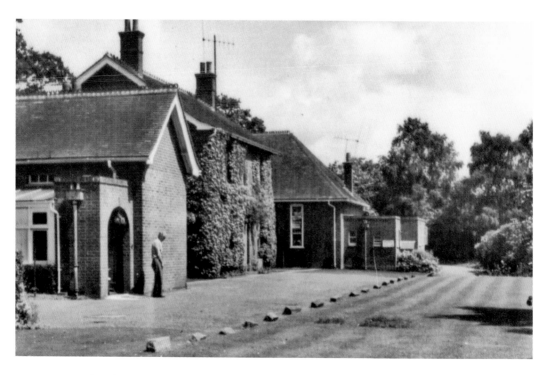

Queen Victoria Cottage hospital

To commemorate the life of Queen Victoria, a cottage hospital was built in Tonbridge at the junction of Quarry Hill and Baltic Road. It survives today as a clinic. Originally, however, it had facilities for four patients, cared for by a staff of three. Within a few years, it expanded to six beds and an operating theatre was added. By 1936, a larger hospital was built half a mile out of town. Since 2010/11, a magnificent modern hospital at Pembury now serves the area's medical needs (*below*).

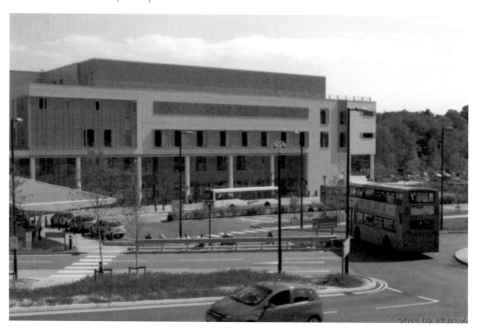

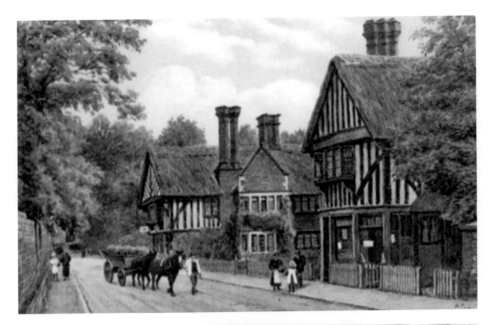

Leigh

Leigh (pronounced 'lye') is a picturesque village 3 miles west of Tonbridge. Surrounded by open countryside, however, it has a strong, individual community spirit. The painted vintage postcard images on this page feature some of its fine listed buildings. Many of these were built by the owners of nearby Hall Place in the nineteenth century, employing excellent architects and local materials.

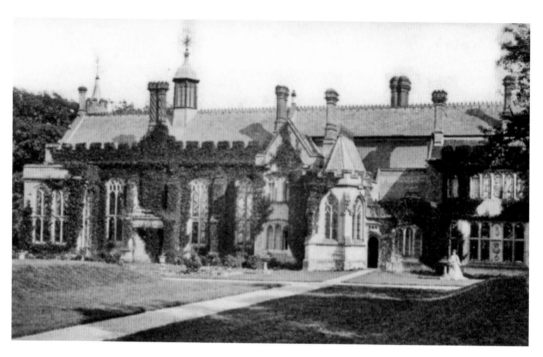

Hall Place I

Before the eighteenth century, Hall Place was probably no larger than a farmhouse. Its tenant, William Heath, then bought the freehold and built a larger mansion in 1790. Later, when ownership passed to Thomas Bailey, there was considerable alteration and rebuilding in the Gothic Revival style. In 1870, the estate was acquired by Samuel Morley for the princely sum of £42,000.

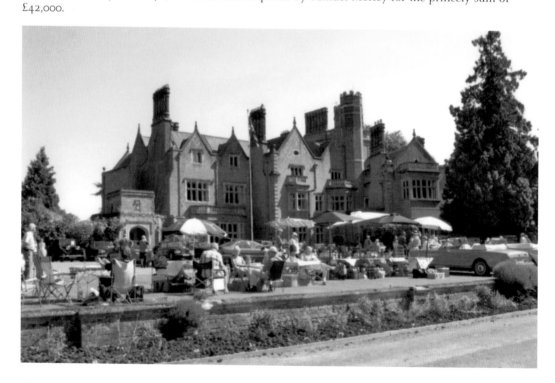

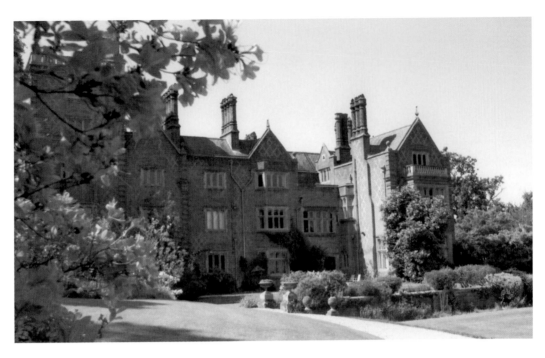

Hall Place II

In 1873, Samuel Morley, the new owner of Hall Place, decided to pull down the existing house and appointed George Devey to design a new one. His son, Samuel Hope Morley, added two adjacent farms to the estate. He was elevated to the peerage in 1912, taking the title Lord Hollenden, and the house still remains in the ownership of the family.

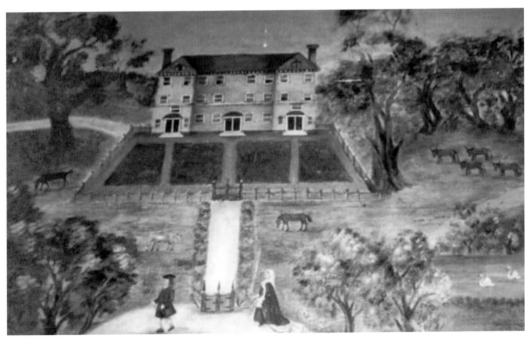

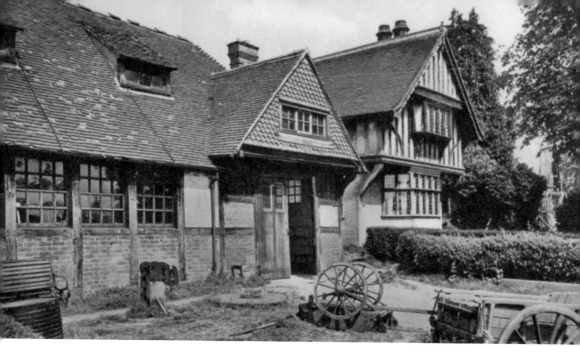

The Old Forge, Leigh

The Old Forge was well-placed opposite the village green to serve all its customers' blacksmith requirements. Close examination of the images on this page show how little has changed to this building over the years, despite its different usages.

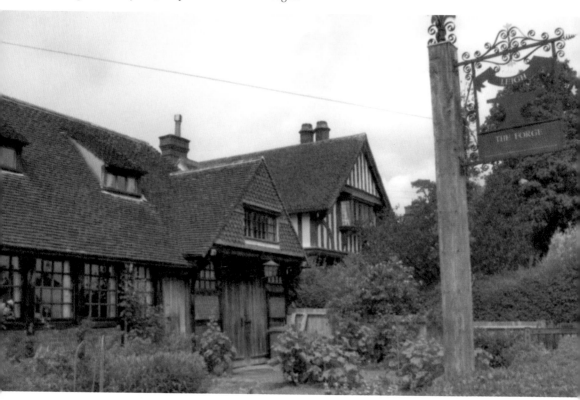

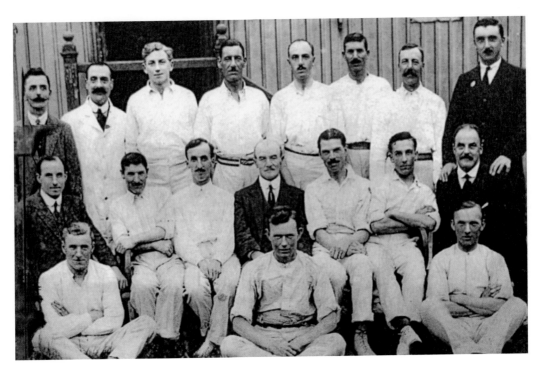

Leigh Cricket Club I

Cricket has been played at Leigh for over 300 years. As one of the world's oldest clubs, it has a long and illustrious history. Above is a formal team portrait from 1919, juxtaposed to a snapshot of a 2012 game.

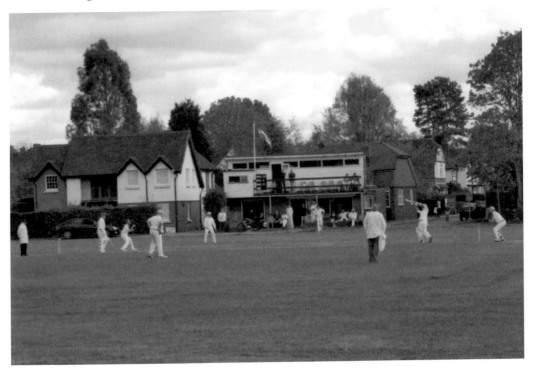

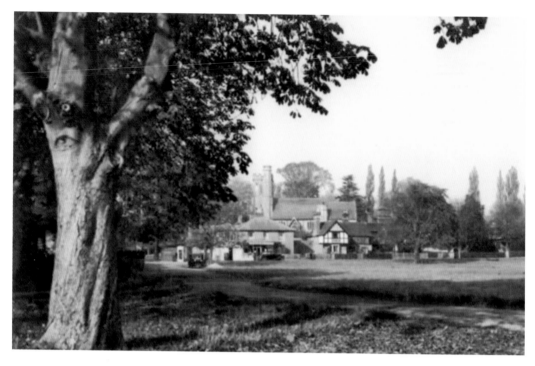

Leigh Cricket Club II

The timeless pictures on this page illustrate the beautiful village green setting for Leigh Cricket Club's home matches. As respected and successful members of the Kent County Village League, the club runs three senior sides and gives strong support and encouragement to its junior players.

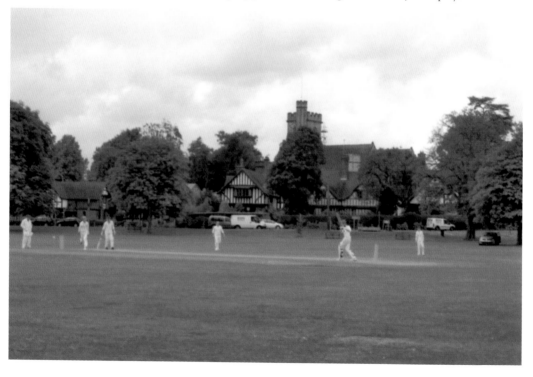

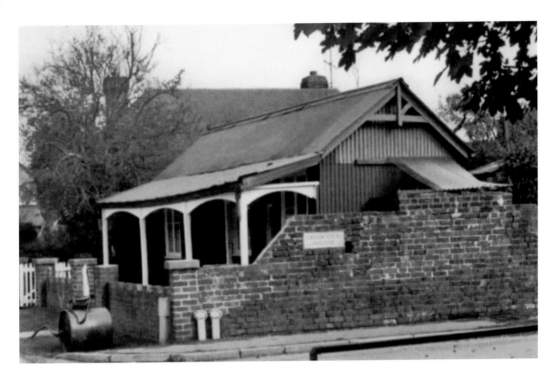

Leigh Cricket Club Pavilion

When Leigh Cricket Club decided to upgrade their old galvanised tin pavilion with a new one, they found that to qualify for grants it was necessary to own the freehold of the ground upon which it stood. For many years, brother and sister Ethel and Gordon Goodwin, who owned this land as part of their home curtilage, were happy to freely lend its use. It is to their eternal credit that they freely donated this ground when approached by Dan Thoroughgood. Their only, very touching stipulation was that they should be treated to gratis annual club subscriptions!

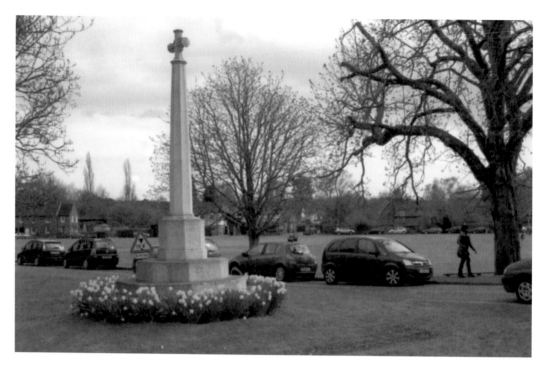

Leigh War Memorial

Erected in 1920 at a cost of over £400, Leigh's war memorial commemorates the lives of thirty-one men who were killed in the First World War. Sadly, the roll of honour includes three brothers, the sons of James and Charlotte Bourner of Forge Square, Leigh, who all died on continental battlefields before reaching their thirtieth birthdays. A further ten servicemen who fell during Second World War are also listed.

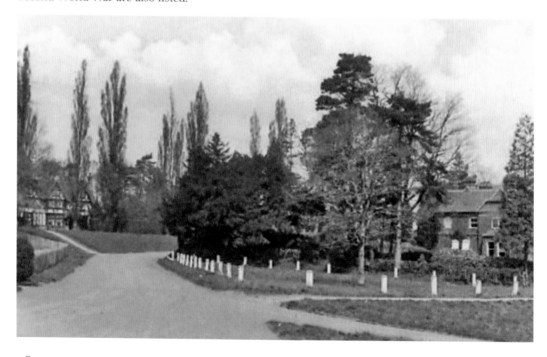

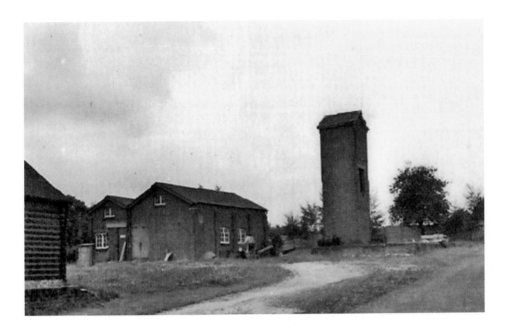

Leigh Powder Mill

The Children family of Ferox Hall, Tonbridge were instrumental in establishing a gunpowder factory at Leigh. Water power and transport were then essential requirements for founding such an enterprise. Demand from the Napoleonic Wars, and later the First World War, created plentiful revenue; however, production ceased in 1934. Some of the old works buildings are pictured Above. Below, is a shot of GSK's now also derelict research facilities. Leigh Historical Society, aided by two grants, investigated the archaeological remains of this industrial site in 2005, and subsequently published two reports into their findings.

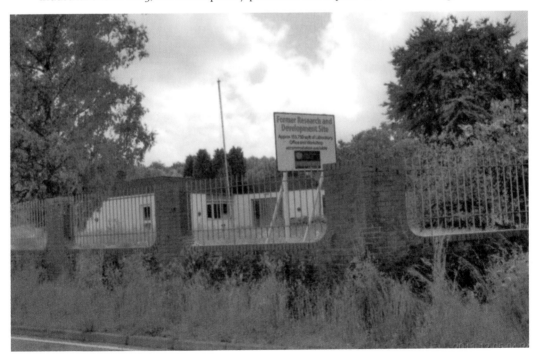

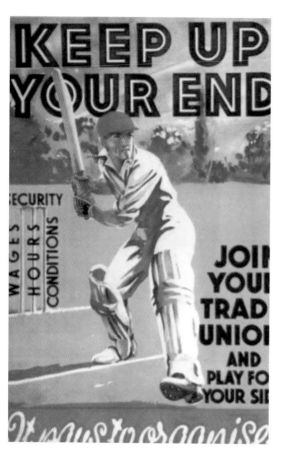

Cricket Ball Makers

Cricket ball manufacture, a descendant of saddle making, was a traditional Tonbridge industry. The River Medway was good for tanning hides, and as the popularity of cricket rose some six or more firms supplied this trade. In Tonbridge itself Dukes were best known, but with retrenchment they amalgamated with five other local producers to form Tonbridge Sports Industries Ltd. The poster, left, encouraged workers to join the union of the Amalgamated Society of Cricket Ball Makers.

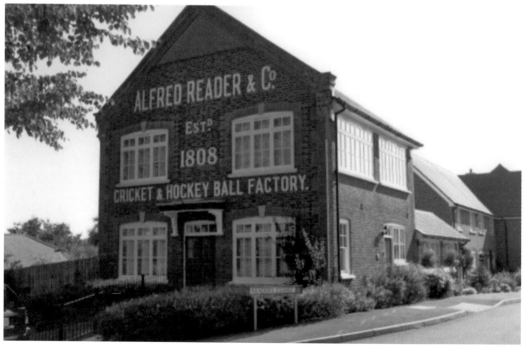

Stock Farming

Although best known for hops and
fruit, this fertile part of Kent also
reared excellent sheep and cattle.
Tonbridge cattle market closed a
number of years ago, so local farmers
switched to Ashford. Opposite is a
postcard image of cows grazing by the
Medway. The overhead photograph,
below, shows an old-style seasonal
collective sheep sale in full swing.

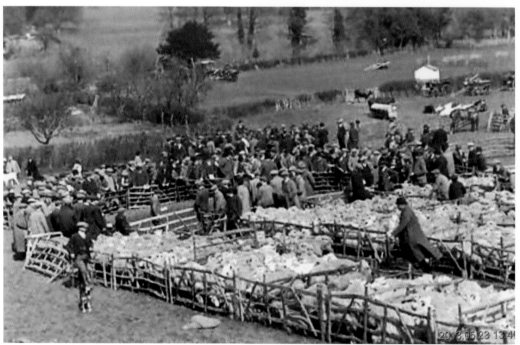

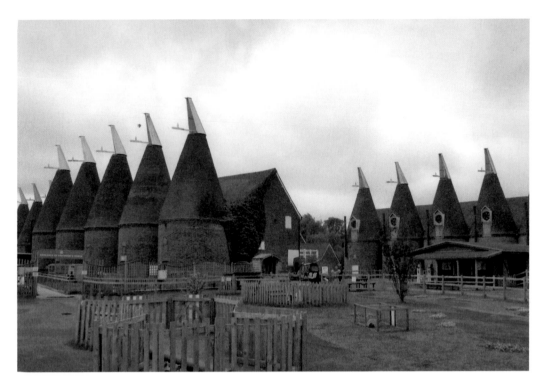

Beltring Oast Houses
The Hop Farm, Beltring, boasts the world's largest collection of oast houses. Whitbred & Co. sold the farm after they gave up beer production. Since then, under private ownership, it has been used for military re-enactment shows and a leisure park.

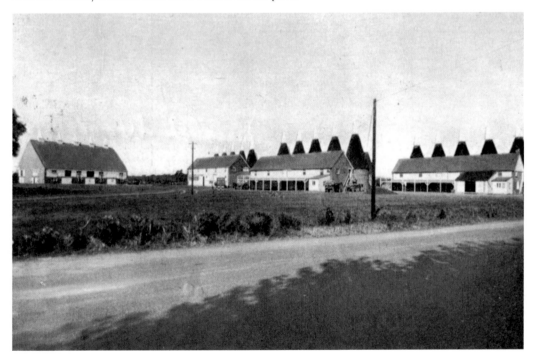

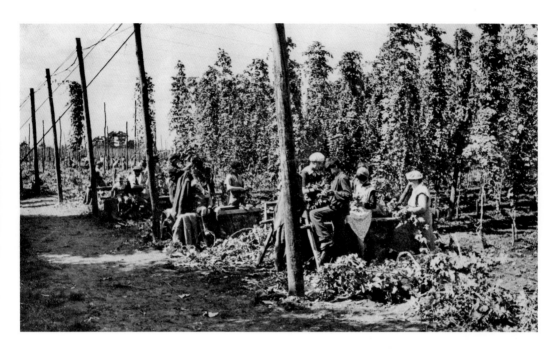

Hop Harvesting I

The hop was once considered a pernicious weed in early medieval times. However, the popularity of beer for as little as 1*d* a pint caused vast quantities of it to be consumed – particularly by manual workers who were then the core of the working population. To harvest the flowers of the hop – a vital flavouring of beer – huge numbers of seasonal workers would travel from London to work in the fields. They travelled to Tonbridge by train and often stayed in crude wooden huts.

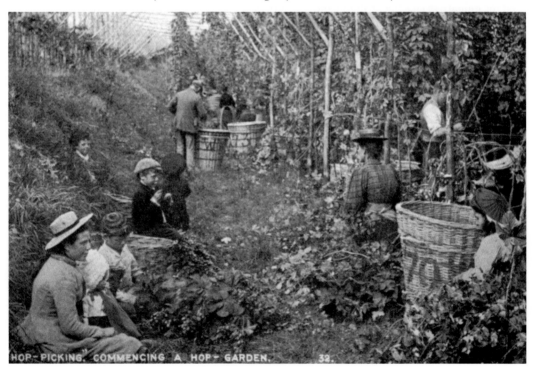

HOP-PICKING. COMMENCING A HOP-GARDEN. 32.

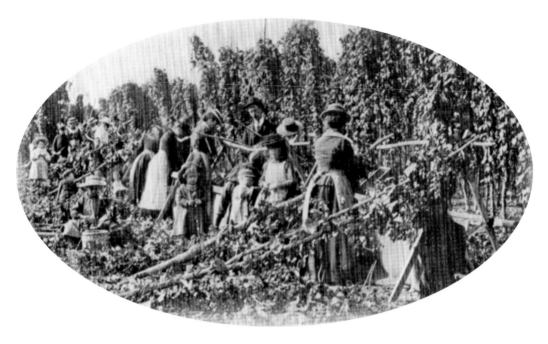

Hop Harvesting II

Hop pickers worked on a piecework basis filling large sacks called pockets. These were then transported to oast houses, where they were emptied out onto drying floors. The picture below illustrates this last procedure before delivery to brewers.

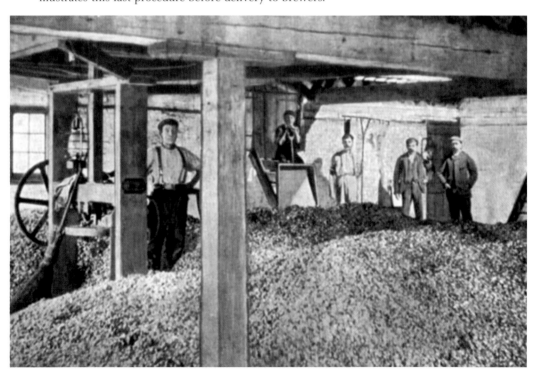

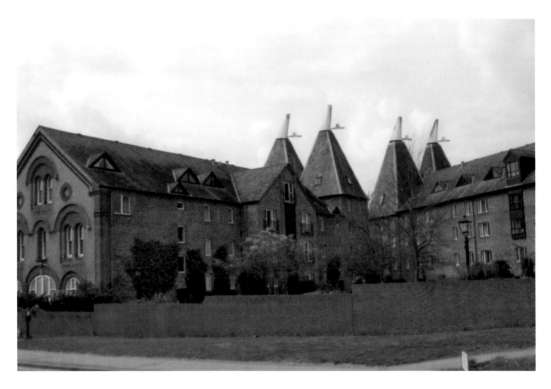

Oast House Conversions

The countryside surrounding Tonbridge is dotted with hundreds of old oast houses bearing silent witness to how popular this intensive form of farming used to be. Fortunately, many of these redundant conical buildings have been converted to elegant period homes, as illustrated here.

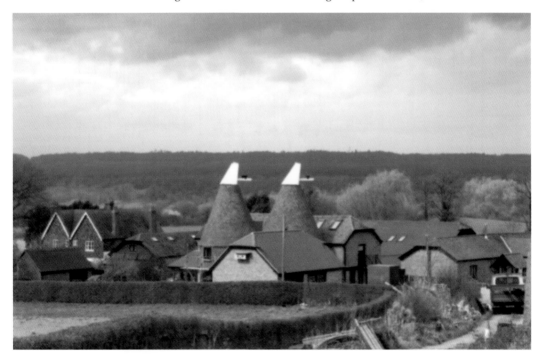

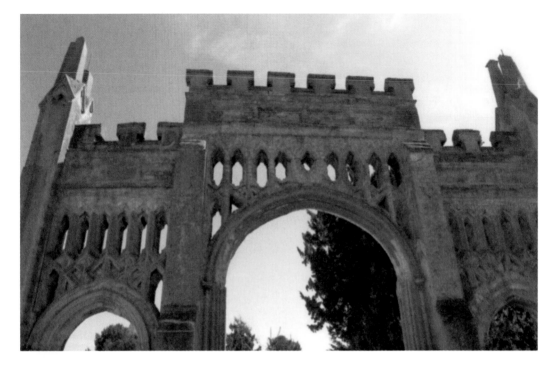

Hadlow

Hadlow is a large village in the Medway valley near Tonbridge. Three mills and a brewery were once situated here. It is home to a large agricultural and horticultural college, which was established in 1968. The display of daffodils on the campus, below, were photographed in the late, cold, spring of 2013. The archway above is the entrance to the famous folly, Hadlow Tower.

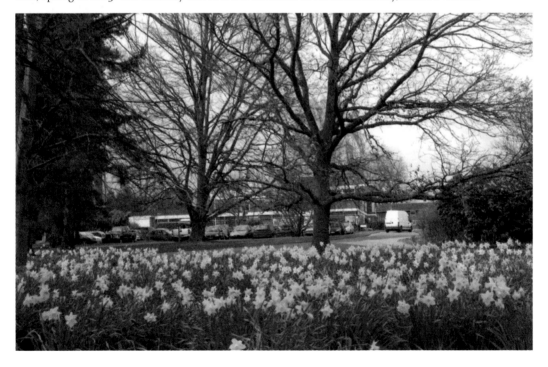

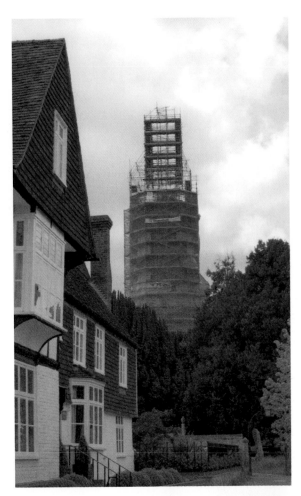

Hadlow Tower I

Hadlow Court Lodge was inherited by Walter May, who subsequently demolished it to build Hadlow Castle in 1786. When his son later inherited this, along with another inheritance from his wife's family, he decided to add a tower designed in matching Gothic style.

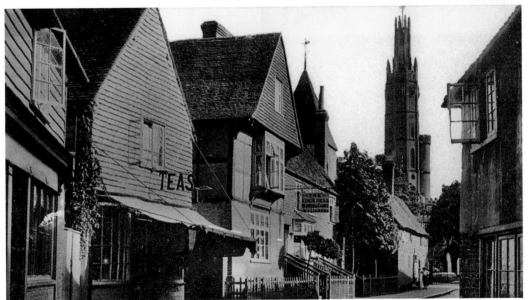

Hadlow Tower II

England's tallest folly was listed as a Grade I building when the adjoining house was demolished in 1951. Following many changes of ownership and extensive damage in the 1987 storm, the monument was left in a dangerous condition so Tonbridge Council had to take action to secure its future preservation. After compulsory purchase, it was sold to Vivat Trust and, with the aid of munificent grants, restored to its former glory. Luxury holiday flats have been constructed within the tower and there are facilities for the use of the local community.

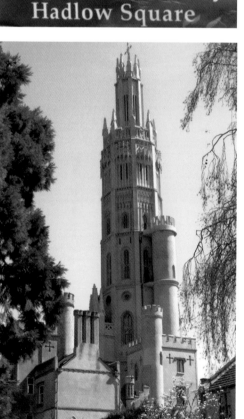

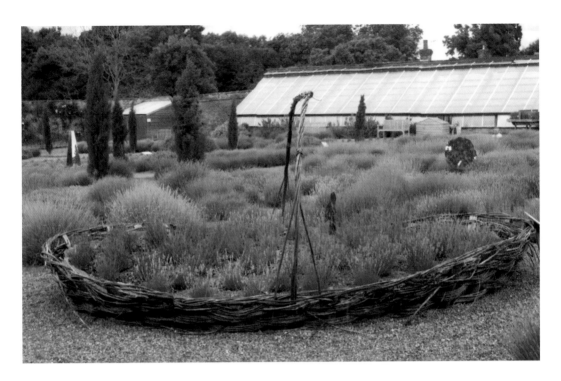

Downderry Nursery

Tucked away down Pillar Box Lane, Hadlow, is specialist lavender producer Downderry Nursery. The proprietor, Dr Simon Charlesworth, has won every award possible for his plants. Indeed, there is no better credential for this business than the large wall of gold Chelsea Flower Show awards that greets visitors.

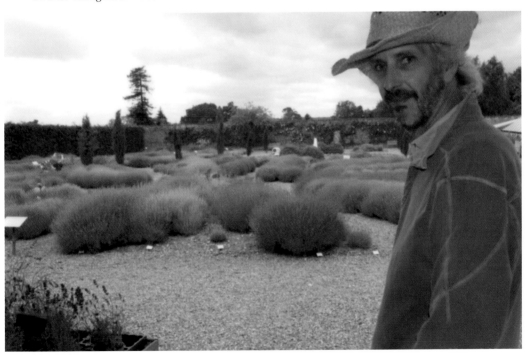

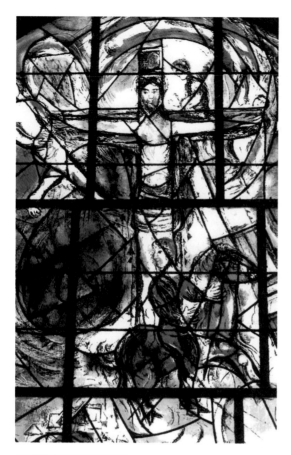

Chagall Church Windows, Tudeley I
Tudeley is the location of All Saints' church, which is thought to be the only church in the world with all its windows in stained-glass, designed by Marc Chagall. The east window (*left*) has superb colour saturation. It was commissioned by Sir Henry and Lady D'Avigdor-Goldsmid in memory of their daughter, Sarah, who died in a boating accident in 1963.

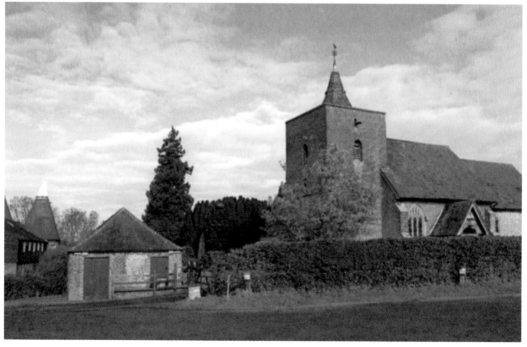

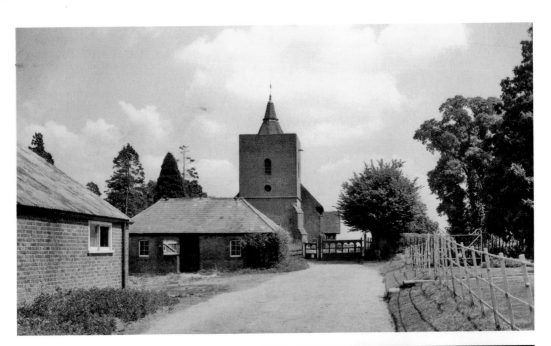

Chagall Church Windows, Tudeley II
Marc Chagall was somewhat reluctant
to undertake the commission for
stained glass in the east window of
Tudeley church. However, he was so
pleased after his work was installed
that he was happy to do all the other
windows. Before her untimely death,
Sarah D'Avigdor had shown an early
interest in contemporary art. She had
bought the first painting that David
Hockney had ever sold, snapping it up
at his student show.

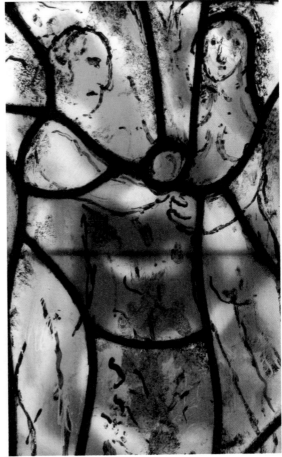

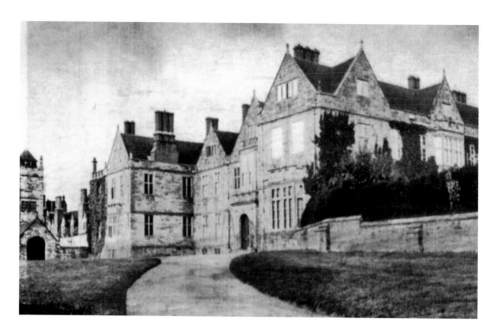

Somerhill

Somerhill is an enormous Grade I listed Jacobean mansion, which is second only to Knole as Kent's largest house. Constructed from Calverley sandstone, the house itself covers an area of 2½ acres. In 1849, Sir Isaac Goldsmid purchased this property and it remained in the ownership of this family until 1980. After much adaptation and restoration, it eventually became a private school in 1993.

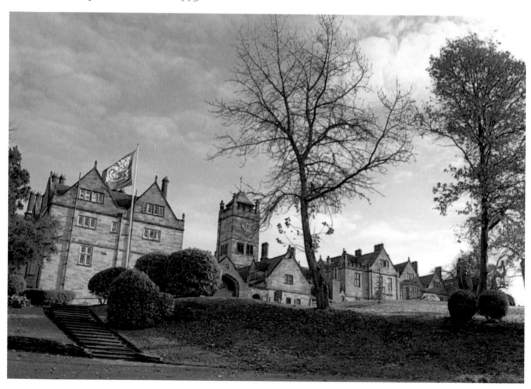

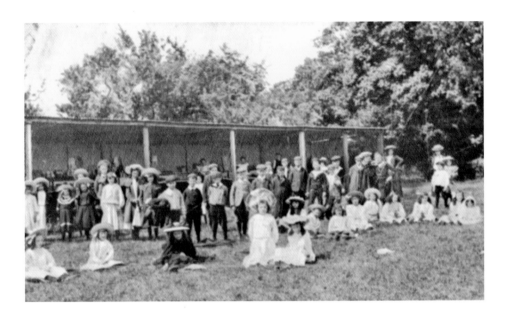

Barden Park Bizaar

The happy Edwardian scene above was photographed at Barden Park, which was a large house built in 1887. Although it is known that the amateur theatricals seen below were performed by a troupe of Tonbridge thespians, no more specific information can be found.

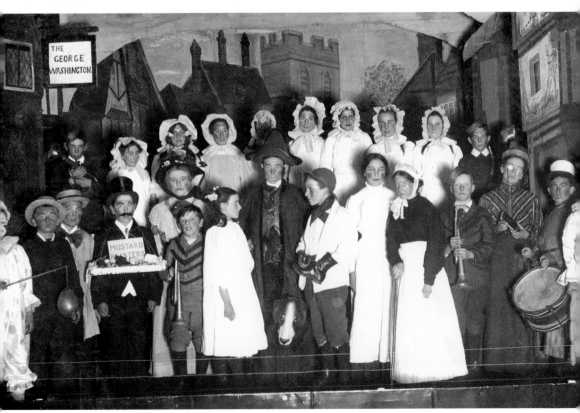

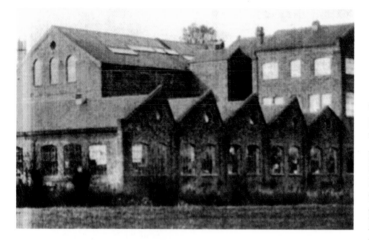

Whitefriars Printing Works
Whitefriars printing press was set up in Medway Wharf Road in 1896. It was the printer of the popular magazine *Punch* and the producer of millions of paperback Penguin books. In its day, this and the Crystalate record works were two of Tonbridge's major employers. The old warehouse site pictured above is now a housing development.

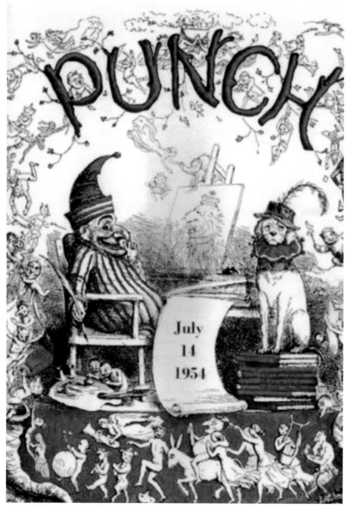

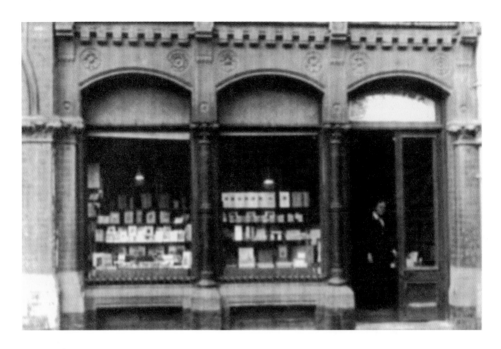

Mr Books

Mark Richardson, also known as 'Mr Books', is Tonbridge's sole independent bookseller. He is pictured below with author Charles Moore at a book signing of his magnum opus, the first volume of Margaret Thatcher's biography. Above is a faded old image of Snellings, an early bookshop in the town.

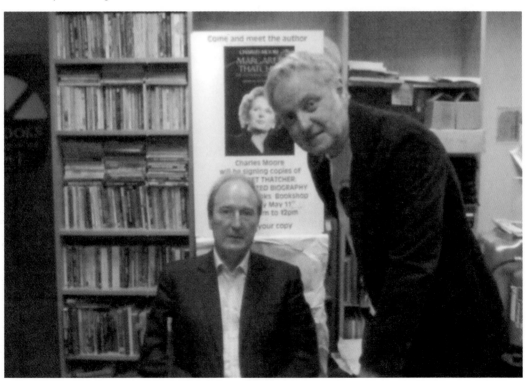

Acknowledgements

First and foremost, a great debt of gratitude is owed to my beloved partner Jocelyn for her ceaseless help and encouragement. Thereafter, considerable appreciation and thanks is due to my wonderful neighbour, Trac Fordyce, and her parents, who have been generous in providing books, pictures and computer wizardry. Last but by no means least, I am delighted to express my sincere thanks to my beautiful friend Joanna Elvy for driving me around Tonbridge and its lovely countryside.